Ethnic Notions

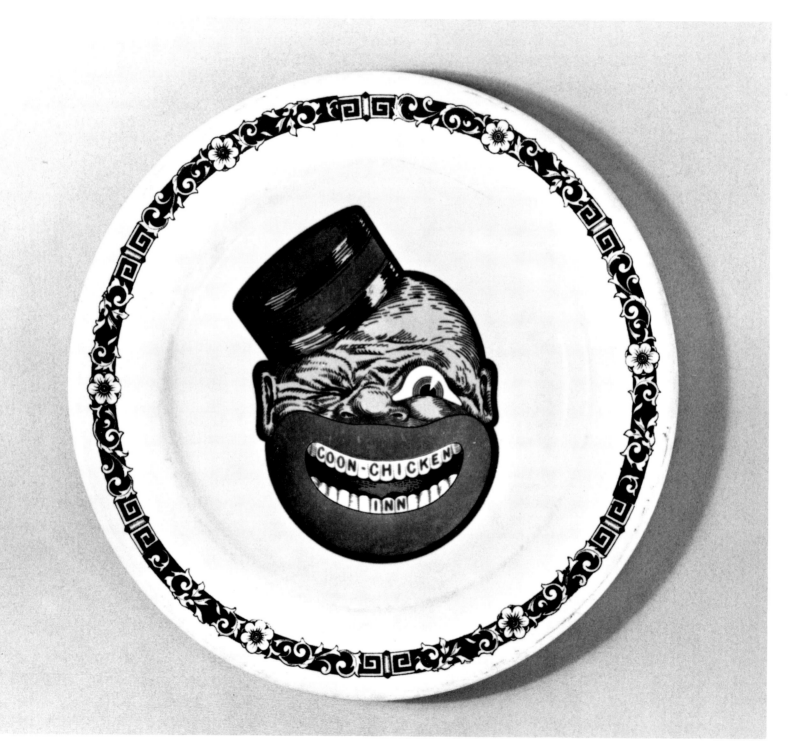

16

Ethnic Notions

BLACK IMAGES IN THE WHITE MIND

*An exhibition of racist stereotype
and caricature from the collection
of Janette Faulkner*

9/12/00

Best Wishes!

September 10 – November 12, 2000

BERKELEY ART CENTER

In memory of Orpha Krinn Gibson.

I am grateful to all my friends and relatives whose effective networking helped me to locate some of the pieces in this collection. And I would like to acknowledge the late Dr. Lorenzo Greene, professor emeritus at Lincoln University, Jefferson City, Missouri, and last of the "Black History Trust." Dr. Greene laid the academic foundation on which I built this collection. I wish to especially express my gratitude to the late Mary M. Turner, assistant librarian at Lincoln University for her never-ending encouragement for me to look at the "other side" of black history.

Janette Faulkner
Berkeley, 1982 & 2000

This catalog is an updated and revised version of the 1982 *Ethnic Notions*, prepared by Robbin Henderson and Adam David Miller. It was designed by Pamela Fabry and edited by Robert Schildgen. Cover design is by Cecilia Brunazzi. Photographs are by Bruce Handelsman, except for images numbered 12, 148, 104 and 166 and images on pages 25, 72 and 73, which are by Theresa Whitener.

BAC gratefully acknowledges support from the LEF Foundation and the California Council for the Humanities

Front Cover: *Sapolio* Advertisement, 1880s, catalog no. 32.

Contents

Foreword

This collection reflects the persistent use of caricature as an art form designed to support a theory of racial inferiority.

I began this collection over twenty years ago, while attending undergraduate school at Lincoln University, Jefferson City, Missouri. During that time I lived with Mary and Robert Turner. Mary, an antique dealer, displayed a large representation of her inventory throughout the house. As I was uncomfortable amidst art glass and rare pieces of furniture, coming from a family of fourteen, Robert, to relieve my discomfort, encouraged me to learn more about antiques. Under their kind tutelage, I learned enough about antiques to be comfortable with them, so that at the end of my first year I moved through the house with the ease of a dancer.

Then Mary invited me to accompany her on her annual summer buying tour in various parts of the state. On our third day out, finding myself bored with the repetition of antiques in the various shops, I entertained myself by browsing through a box of paper memorabilia. I was intrigued by a picture post card with the image of a black man on it. His mouth was exaggerated in width, depth and color. A huge tongue extended to the middle of his chin. Every other tooth was missing. The picture's caption read: "dares mo laak dis bac home." After I had recovered from my fright and revulsion, Mary suggested I look for more similar items. Thus a collector was born!

This collection contains a large number of functional items dating from 1847 to the present. It includes such items as pencils, tablets, silver spoons, books, games, sheet music, post cards, tobacco jars, candy tins, and toys. Many of the American items were produced by well-known artists, illustrators and manufacturing companies. Most of the foreign pieces are recognizable by geographic location, i.e., Meissen ware from Germany.

The stereotyping, style, composition, and line of the items reflects society's responses to slavery, the Emancipation Proclamation, World Wars I and II, and the Civil Rights Movement of the sixties as experienced in this country and as these events were perceived abroad.

This collection focuses on caricatures of blacks which have been used to convey fear, support, or rejection of

assigned roles. In America, caricature was used to maintain the exclusion of blacks and insure total separation of the races. European caricatures supported America's need to legislate exclusion of African Americans.

The physical distortion of the black image is most exaggerated in the depiction of the mouth, eyes and hair. The mouth is usually opened wide and filled with very large, carnivorous-looking, extra-white teeth surrounded with large, thick, ruby-red lips. Eyes are usually large, bulging and fearful, with exaggerated whites. Hair resembles the fright wig of the stage and is usually unkempt. Blacks are often shown in connection with the chicken, coon, watermelon, alligator, or bale of cotton. This collection reflects the persistent use of caricature as an art form designed to support a theory of racial inferiority and to predispose an emotional response.

Understanding caricature as an art form has enabled me to transcend my early days of anger and revulsion. I learned to integrate the artistic endeavor with the psychological and socio-political ideas manifested in the collection, but, since I was cognizant of myself as a target of racism and oppression, my transition was not free of pain. Though aware of their racial poison, I now have come to see in the more outstanding pieces expressions of style, form and technical skill. This transition has freed me to share with others the collection and the educational proccss I have undergone.

A lot has changed for me and my collection since the last exhibit, almost 20 years ago. I've aged (now retired) and unfortunately so have some of the pieces: so much so that they were not included this time. The black antique and collectible item has become trendy and marketable. This current collectibility is evidenced by the major import of items manufactured in Taiwan, Germany, China, Japan and Russia. My research indicates that China and Russia did not begin manufacturing and exporting these items until the mid-1970s. Surely some of our cultural critics have an explanation for this phenomenon. American manufacturers have also been busy reproducing the old images and creating new ones, as seen in some of the pieces in this exhibit. Many of the contemporary pieces reflect our society's response to integration, immigration, affirmative action and interracial marriages.

Caricature of blacks is once again acceptable and passes unremarked because of the daily presence of distorted images. CD covers featuring stereotypes, a resurgence of "blacking up" by white and nonwhite actors, and the general presentation of cartoon figures with stereotyped characteristics indicate this. One measure of current acceptability is that some blacks are reproducing the negative, exaggerated black image as an art form and source of livelihood.

Gathering antique and collectible black images has become a costly hobby. My collection now includes stereotypes of other groups, including Chinese (the "coolie"), Latinos (the "sleeping Mexican"), Irish (Protestant or Catholic images), children (abusive or exploited images) and women (sexist images). These items are less expensive and as available as images of blacks.

Thanks to the Berkeley Art Center, *Ethnic Notions* has gained international recognition. These efforts to educate the public may account for the marked decrease I have found in contemporary distortions of images of Japanese and Native Americans. However, we still have a long "row to hoe" before we can rid ourselves and society of racism.

Janette Faulkner
Berkeley, California
June 2000

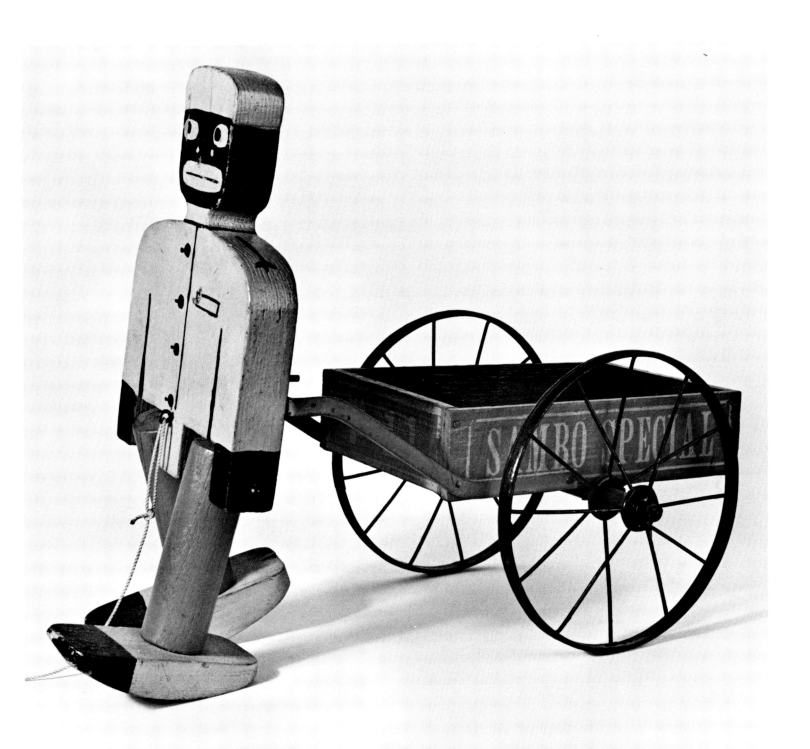

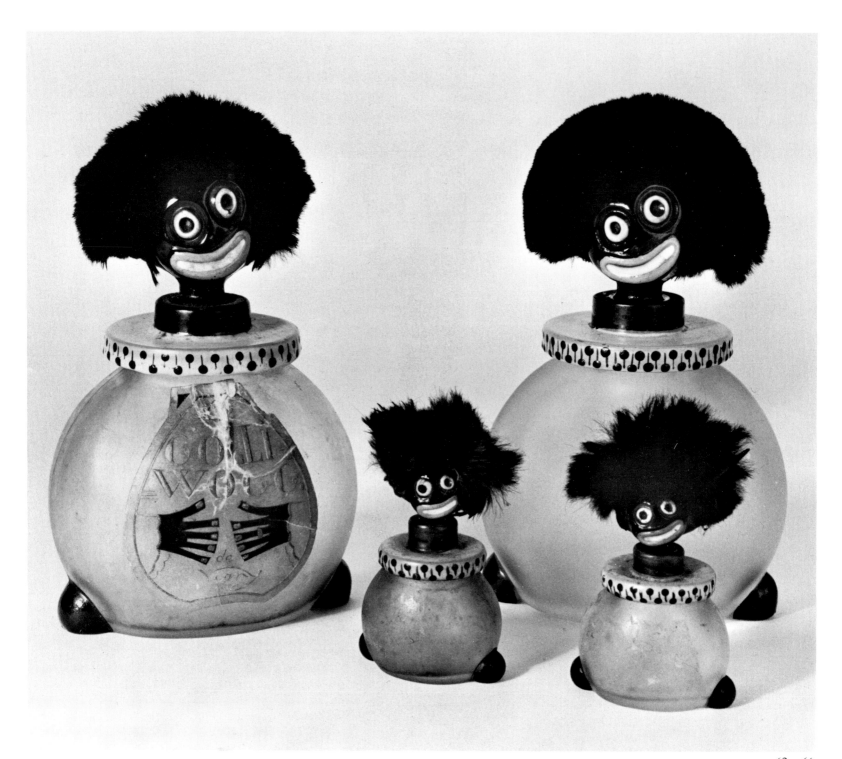

63 — 66

Introduction

Janette Faulkner's collection, first presented at the Berkeley Art Center in 1982, continues to reveal the values of the society that produced these items, and acts as a sort of cultural barometer of the racial climate over the past 150 years. In spite of the efforts of civil rights activists and cultural critics, racial stereotypes are still being created and perpetuated, and thus continue to affect our perceptions and attitudes. Ms. Faulkner has accumulated these items over nearly 50 years, and was the first collector of such artifacts to publicly present them. The persistent, mute presence of these images in the American household, and similar stereotypes found in film, television, toys and cartoons, undercuts the legal remedies that have been applied to accord African Americans their civil rights.

Much of the subversive power of such objects comes from the fact that they are regarded as acceptable and their utilitarian function renders them unremarkable. The attitudes and values they convey subtly invade our consciousness and we reflect on their meaning as little as we would upon a kitchen appliance. According to scholar Patricia A. Turner, only during the 1960s and '70s did the production of these artifacts decline in the United States. Following the gains of the civil rights era, there developed a heightened awareness of the racism implicit in these caricatures and for a brief period, they were widely perceived as unacceptable.[1]

Novelist Alice Walker writes:

> These caricatures and stereotypes were really intended as prisons....prisons of image. Inside each desperately grinning "sambo" and each placid 300-pound "mammy" lamp there is imprisoned a real person, someone we know. If you look hard at the collection

I see our brothers and sisters, mothers and fathers, captured and forced into images they did not devise, doing hard time for all of us.

ALICE WALKER

[1] Patricia A. Turner, *Ceramic Uncles & Celluloid Mammies: Black Images and Their Influence on Culture*, Anchor Books, New York, 1994.

and don't panic...you will begin to really see the eyes and then the hearts of these despised relatives of ours, who have been forced to lock their true spirits away from themselves and away from us....

That is the way I now see Jan Faulkner's collection. I see our brothers and sisters, mothers and fathers, captured and forced into images they did not devise, doing hard time for all of us.

We can liberate them by understanding this. And free ourselves. [2]

The collection has continued to grow, and it is significant that a number of the items are of recent manufacture. The persistence and pervasiveness of these stereotypes is demonstrated by these new items and the incredible size and variety of the collection.

The late African American Studies scholar, Barbara Christian, observed:

I have students both black and white who *believe* these images, because it has become a thread throughout the major fiction, film, and popular culture, even the jokes black people make about themselves. It has become a part of our psyche. It is a real indication that one of the best ways of maintaining a system of oppression has to do with the psychological control of people.[3]

Stereotyping not only degrades its victims, but dehumanizes its perpetrators, poisoning them with contempt and destroying the relationships with others that enrich life and create emotional depth. Ignorance of the history of racism and its consequences merely perpetuates this condition.

Stereotypes may also be internalized by their victims, who experience the destructivenss of externally imposed identities that continue to damage the self-esteem and undermine the dignity to which we are all entitled. This collection is thus important for blacks, as well as for whites and other non-blacks.

The exhibition challenges beliefs that such items are innocuous, have little impact and do not influence our notions of ourselves and others. Many witnesses to the 1982 exhibit were visibly shaken. A white woman viewer who grew up in Maine and had never seen an African American until she was an adult, reported finally comprehending the way such images had shaped her prejudices. From her first encounter with blacks, she was uncomfortable in their presence, although she knew it was wrong to feel this way. Seeing the collection, she remembered for the first time the presence of such objects in the homes of relatives when she was young. She realized that the "bad" feelings did not rise naturally in her, but were shaped by these icons of contempt. Seeing this material allowed her to move forward, understanding that she was not a bad person, but someone whose perceptions and feelings had been distorted by a racist environment.

Since its debut, this disturbing collection of what Dr. Turner calls "contemptible collectibles"[4] has inspired the production of Marlon Rigg's 1986 film documentary, using the the term Faulkner coined, *Ethnic Notions,* as its title. Portions of the collection were shown at the Alternative Museum in New York City and the Museum of Arts and Sciences in Macon, Georgia, in 1988 and 1989. Other collectors have lent similar material for public viewing in locations across the

[2] Alice Walker, unpublished letter, 1981.
[3] Quoted in Marlon Riggs' film *Ethnic Notions,* 1986.
[4] Patricia A. Turner, *Ceramic Uncles.*

country, and the market for "contemptible collectibles," once almost clandestine, is booming unashamedly. Over the past 20 years, books and articles have been published analyzing these stereotypes in manufactured objects, as well as in film, television, video games, children's collectibles and other expressions of popular culture. There are now even collector's guides listing the market value of these objects. Most disturbingly, 21st century reproductions of items manufactured in the mid-20th century have themselves become collectible.

The Berkeley Art Center's mission to respond to its constituency by exploring current social and philosophical concerns is evident in this exhibition. Racism is one of the most profound and insidious of America's social problems. As research on the 1921 genocide against Tulsa, Oklahoma's, African American community is finally reported in the mainstream press, the subject of compensation for centuries of slavery and for the social, political and economic oppression that followed it has entered the national dialog. *Ethnic Notions* adds to the growing body of material documenting the violence perpetrated against African Americans and helps to build the case in favor of reparations.

Our goal here is to provide the viewer with a means to identify specific stereotypes, to show how stereotype functions to support notions of racial inferiority and how these images describe and reinforce power relationships. We ask our audience also to consider the consequences for those who resist—who refuse to conform to the stereotype. The ultimate goal is to encourage viewers to re-evaluate their own attitudes and to foster positive change in race relations.

I am grateful to the Berkeley Art Center's Board of

Directors, which has unswervingly supported the mounting of this controversial exhibit, and to our staff, including Yvette Deas, Patrice Wagner and intern Anna Wilder who cheerfully worked many extra hours, in spite of the painfulness of the material. We also thank: Cecilia Brunazzi, Nancy Ippolito, Daphne Muse, Evelyn Orantes, Crystal Hoyle, Jos Sances and Robert Schildgen for the invaluable contributions of time and expertise in so many areas of this complex project. The wall text for the exhibit is based on the work of Jim Grossman and Shirley Ann Wilson Moore, who researched and wrote the original text in 1982. The insights and scholarship of Leon Litwack, Patricia A. Turner, Judith Wilson and Theresa Whitener have been indispensible. We wish to especially thank Marina Drummer of the LEF Foundation whose support over the years for projects dealing with issues of peace and justice has been exceptional and courageous. This catalog would not have been possible without her. Finally, I thank Jan Faulkner who has had the courage, insight and generosity to face this material and to share it with us.

Robbin Henderson
Director
Berkeley Art Center 2000

13

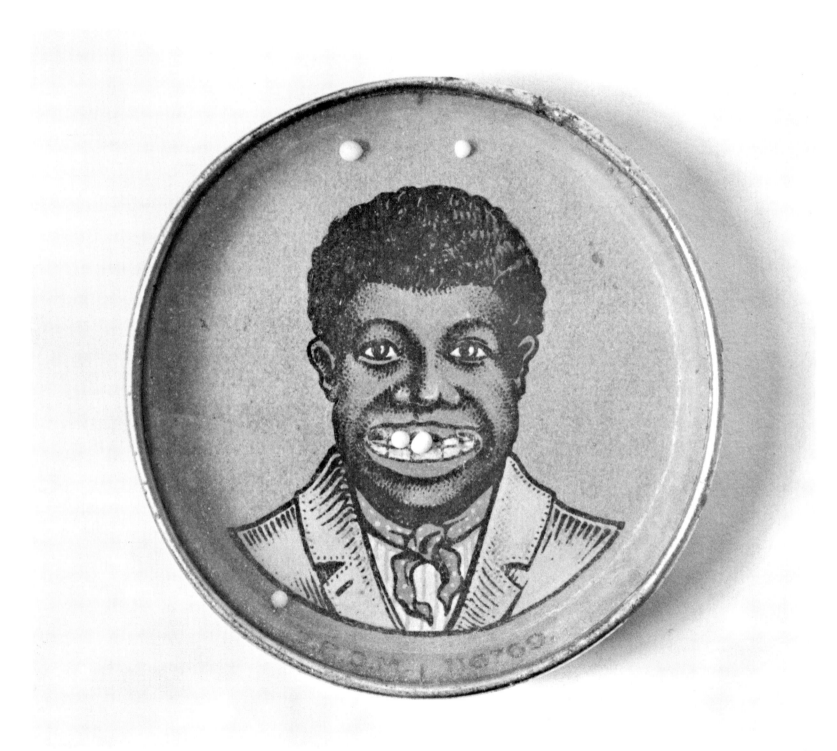

Throughout the experience of black men and women in American society, the denial of their humanity has been used to keep them "in their place." To think of them as a childlike and dependent race, suited only for positions of service and possessing neither the feelings nor the sensitivities of white people, made it that much easier to exact from them the hard work and submission necessary to fill the labor needs of white America. During slavery, custom, habit, and force largely defined the behavior expected of them at all times. The black man was less than a man—he was a "boy." The black woman was less than a woman—she was a "girl." In old age, each might be accorded the honorific title of "auntie" or "uncle." And some slaves recalled neither titles nor names. "We hardly knew our names," said Sallie Crane of her bondage. "We was cussed for so many bitches and sons of bitches and bloody bitches, and blood of bitches. We never heard our names scarcely at all."

What had been firmly planted in the white mind was an image of the race as childlike, irresponsible, ignorant, and submissive. And once whites had come to accept these traits as peculiar Negro characteristics, any black man or woman who behaved otherwise was viewed as abnormal, even menacing. "The Negro as a poor ignorant creature," Frederick Douglass observed, "does not contradict the race pride of the white race; he is more a source of amusement than an object of resentment." As long as he conforms to the popular conception of his character and "consents to play the buffoon," he is tolerated. While "in his downward course," Douglass perceived, the Negro "meets with no resistance," yet "his step upward is resented and resisted at every step of his progress. . . . As appendages to white men we are universally esteemed; as independent and responsible men we are universally despised."

For black Americans, the experience of enslavement necessitated bitter lessons in the arts of survival—in the uses of humility, incomprehension, and evasion. Each

The Blues Keep Falling

Leon F. Litwack
Professor of History
University of California, Berkeley

I am invisible, understand, simply because people refuse to see me. When they approach me, they see only my surroundings, themselves, or figments of their imagination — indeed, everything and anything except me.

RALPH ELLISON

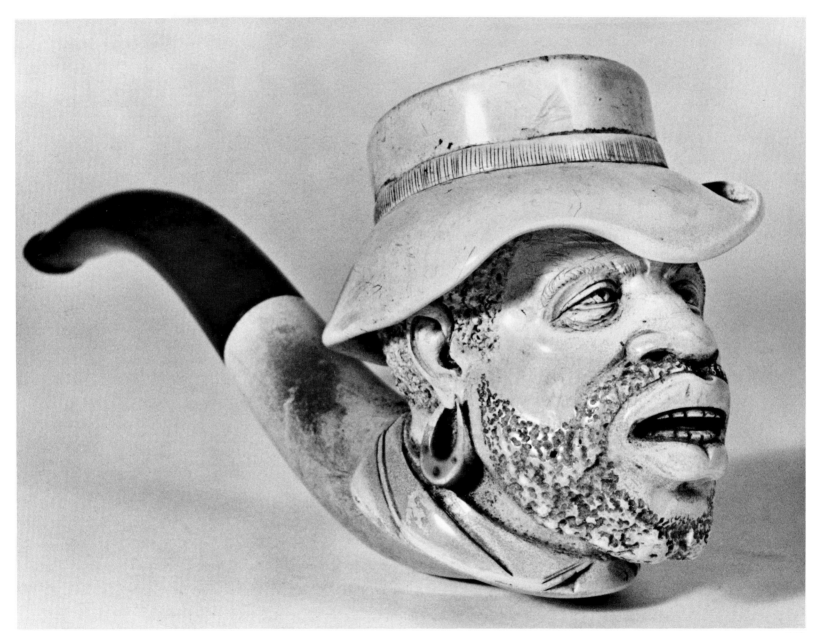

black man and woman needed to master the techniques by which feelings and emotions were masked — the hat in hand, the downcast eyes, the shuffling feet, the fumbling words. The slave's "mask of meekness," Ralph Ellison has suggested, "conceals the wisdom of one who has learned the secret of saying the 'yes' which accomplishes the expressive 'no.' " Even as enslaved black men and women invoked the "darky act," they had to learn at the same time to live with the uncertainties of family life, the drab diet of "nigger" food, the whippings, the humiliations, the sexual exploitation, and the excessive demands on their labor. The quality of bondage to which they submitted could be measured neither by the number of beatings they sustained nor by the privileges and indulgences they enjoyed. What took the heaviest toll, as W. E. B. DuBois observed, had to be "the enforced feeling of inferiority, the calling of another Master; the standing with hat in hand. It was the submergence below the arbitrary will of any sort of individual."

Emancipation introduced still other forms of white duplicity and coercion. The attitudes and behavior which had justified and underscored enslavement persisted in different guises, and the theory of Negro inferiority blunted the North's commitment to racial equality even as it shaped the white South's response to the post-war experiment in bi-racial democracy. To retain the labor of his former slaves, the former master cast himself in the familiar role of the beneficent protector, exercising a paternal and providential vigilance over a helpless, childlike, and easily misled race. Consistent with the view that slavery had been a necessary condition for a people unable to look after themselves, whites settled for a forced dependency which allowed the freedman little or no opportunity to prove his own individual worth. To think, after all, that black men and women could succeed as a free people defied logic and nature, violated prevailing stereotypes, and contradicted the very reasons they had been held as slaves.

While claiming that blacks were incapable of achieving economic independence and social and political equality, the dominant society betrayed the fear that they might. The protection afforded newly freed black Americans during Reconstruction, although enshrined in the Constitution and federal laws, was effectively undermined in the last two decades of the nineteenth century. The need to do so was self-evident to the white South. Freed from the restraining influence of slavery, black people were viewed as retrogressing toward a natural state of bestiality. Equally urgent, a new generation of blacks had emerged which had never felt the restraints of enslavement. In southern literature, it became customary to contrast the "old time darkeys" and the "New Negro" in ways that suggested a renewed threat to white supremacy. If these people remained in the presence of whites, they should not be permitted to contaminate the dominant race, neither at the polling place nor in day-to-day social relations.

Mississippi set the pattern of disenfranchisement in 1890, based on the perception of blacks as by nature inferior and ignorant and hence unfit to vote. Between 1890 and 1910, blacks were practically disenfranchised in nearly every southern state. Where custom and etiquette had previously defined the social relations between whites and blacks, the white South moved at the same time to write those customs and that etiquette into the statute books — to segregate the races systematically in practically every situation in which they came into contact with each other. The campaigns to disenfranchise and segregate blacks encouraged simultaneously an unprecedented era of racial violence. How many black men and women were beaten, flogged, mutilated, and murdered in these years will never be known. Nor could any body count reveal the barbaric savagery and depravity that characterized assaults on black men and women in the name of restraining their savagery and depravity — the severed ears and entrails, the mutilated sex organs, the burnings at the stake, the open display

of skulls and severed limbs as trophies. (W. E. B. DuBois tells of seeing the severed fingers of a lynched black man prominently displayed in the window of an Atlanta butcher shop.) In the first decade of the 20th century, a person was lynched approximately every fourth day, and nine out of ten victims were black. By 1946, an estimated 4000 black Americans had been lynched in the South.

To counter criticism of this barbaric practice, white Southerners embellished the view of the inhumanity of blacks. No matter how many whites condemned lynching, the dominant racial views which fed such violence remained essentially unchanged. Historians provided a distorted version of Reconstruction that dramatized the need to repress blacks. The rapidly emerging social sciences provided additional footnotes to traditional racist assumptions about the character and capabilities of blacks. And those assumptions in turn encouraged and explained still further oppressive racial practices. If black people were a source of social danger and contamination, the need to quarantine them could hardly be questioned.

In the North, patterns of racial discrimination prevailed in employment, housing, and education. If racial tensions were less volatile than in the South, if segregation patterns were less rigid, white northerners nevertheless shared with white southerners a conception of the Negro as an inferior being. In newspapers and popular literature, he was treated, at best, as a source of comic relief. "Why," asked one black editor, "must the newspaper Negro always appear like a dime museum minstrel — and the end man at that?" To *Nation* magazine, the difference in racial attitudes and practices between the North and the South reflected not northern moral superiority but numbers — the substantial black population in the South, including a majority in some states and counties. What the South faces, explained *Nation*, is a problem which no northern state had ever been called upon to face "and which we have no doubt

none of them would with equanimity or in a spirit of strict legality. We all know we should be greatly alarmed by the prospect of anything of the kind in Massachusetts or New York or California."

To measure the pervasiveness of racism is not simply to recount the lynchings, the race riots, and the legislative enactments and court decisions which fixed the blacks' position in American society. What fed, sustained, and explained the need to repress blacks — North and South — was the familiar conception of them as a separate and inferior species. Racist tracts and books, such as Charles Carroll's *The Negro a Beast*, published in 1900, elaborated on the subhuman quality of the Negro race. Far more durable and influential, however, in shaping the popular image of black men and women were the popular novels, the items appearing regularly in newspapers and magazines, the dialect stories, the cartoons, the stage shows, and the appearance of those artifacts that comprise Jan Faulkner's collection, *Ethnic Notions* — all of these featuring caricatures of blacks which exaggerated and distorted their physical appearance and made a mockery of their aspirations. What had been described as "the stock Negro character" was an emotional half-wit, a buffoon, carefree, improvident, shiftless, immoral, irresponsible, and ignorant, incapable of comprehending complex ideas, and given to the use of words he neither understood nor could properly pronounce.

Before the Civil War, southern writers, if they mentioned slaves at all, tended to romanticize the loyal and contented mammy, proud of her white folks, and the good-natured, obsequious house servant. But this idealization of the slave, as historian Winthrop Jordan has suggested, did not become popular until the white South chose to defend slavery against outside criticism and internal threats. In the literature of the seventeenth and eighteenth centuries, the slave was viewed more often as unmanageable and dangerous, as a rebel in the making who posed a threat to the internal security of

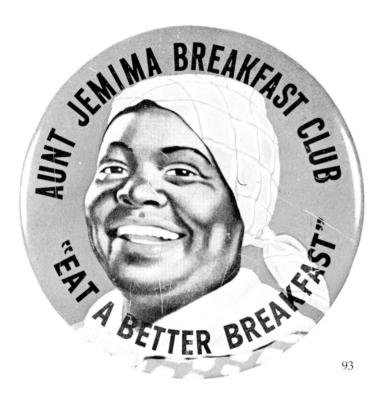

93

white society. But with the Nat Turner rebellion and the abolitionist attacks on slavery, the white South countered with Sambo — the "happy," "contented," "loyal," and "harmless" slave and perpetual child. That characterization reflected white needs more than it did reality; nevertheless, it came to dominate the literature of the South, as it would subsequently shape the portrayal of blacks on the minstrel stage and on the screen. With the release of *The Birth of a Nation* in 1915, as Ralph Ellison has observed, "the propaganda of subhuman images of Negroes became financially and dramatically profitable. The Negro as a scapegoat could be sold as entertainment, could even be exported. If the film became the main manipulator of the American dream, for Negroes

that dream contained a strong dose of such stuff as nightmares are made of."

With equal forcefulness, dehumanizing portraits of black men and women were imprinted on the white mind in the commercial products of white America. The "picturesque" Negro, replete with banjo eyes, saucer lips, and an obsequious smile, was marketed as a suitable household adornment. Whether as a mammy doll, a clock, a savings bank, a letter opener, a salt and pepper shaker, a hitching post, or as an advertisement for pancake batter, baking powder, and breakfast cereal, these artifacts and adornments entered the homes of Americans and became a part of the American Way of Life. And in depicting black people as minstrel types and in distorting their physical characteristics, these items reinforced the notion of such people as subhuman or, at best, as picturesque appendages of American society.

The images were never neutral, neither in their presentation nor in the uses to which they were put. The image of the black man as an unreliable and shiftless incompetent shaped his employment opportunities, confining him to positions of service and hard labor that required the least skill and knowledge and provided the least income. The image of black people as incapable of reaching higher levels of intelligence shaped and curtailed their educational opportunities. The textbook image of black people as contented and loyal slaves or as wretched and easily misled freedmen shaped early perceptions of blacks in the classroom. (A 12-year-old black girl wrote in 1903: "I am ashamed of the names that we are called in the standard history, 'slaves and niggers,' and when we read that part of it the white children look at us real funny.") The image of the ignorant black man rationalized his exclusion from the polls and juries. The image of the race as degenerate and given to uncontrollable sexual and criminal urges explained the need to segregate them rigidly and to lynch them occasionally. The image of the black man as less than a man made it

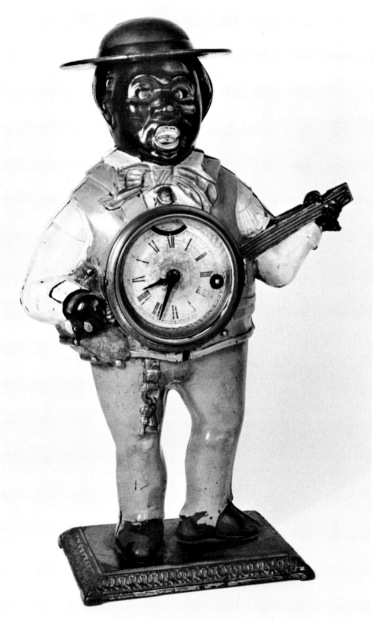

that much easier to make him the butt of the white man's humor and the victim of white terrorism.

To endure, to survive was never easy. In slavery, black men and women managed to create a reservoir of spiritual and moral power and kinship ties that enabled them under the most oppressive of conditions to maintain their essential humanity and dignity. As free men and women, they waged a continual struggle to overcome illiteracy, to develop their own community institutions and cultural forms, and to achieve political and economic equality in a society which viewed such equality as impossible for an inferior race and feared any evidence to the contrary. If they were forced to accommodate, they did not necessarily submit. There was a difference, and few articulated it more eloquently than did Nate Shaw, an Alabama sharecropper.

> I've gotten along in this world by studyin the races and knowin that I was one of the underdogs. I was under many rulins, just like the other Negro, that I knowed was injurious to man and displeasin to God and still I had to fall back. I got tired of it but no help did I know; weren't nobody to back me up. I've taken every kind of insult and went on. In my years past, I'd accommodate anybody; but I didn't believe in this way of bowin to my knees and doin what *any* white man said do.... I just aint goin to go nobody's way against my own self. First thing of all—I care for myself and respect myself.

Even as the patterns and artifacts of racism persisted into post–World War II American society, many of the same oppressions, anxieties, and frustrations excluded blacks from the mainstream of American life. In the 1930s, W. E. B. DuBois warned his people that they faced not merely the rational, the conscious determination of whites to oppress them but "age long complexes sunk now largely to unconscious habit and irrational urge." That warning retains its forcefulness today. The memorabilia in *Ethnic Notions* are a reminder, not so much of the past as of the dangers of the present.

References

John Hope Franklin, *From Slavery to Freedom: A History of Negro Americans* (5th ed., New York, 1980).

Winthrop D. Jordan, *The White Man's Burden: Historical Origins of Racism in the United States* (New York, 1974; abridged ed. of *White Over Black*).

John W. Blassingame, ed., *Slave Testimony: Two Centuries of Letters, Speeches Interviews, and Autobiographies* (Baton Rouge, 1977).

Kenneth M Stampp, *The Peculiar Institution: Slavery in the Ante-Bellum South* (New York, 1956).

John W. Blassingame, *The Slave Community: Plantation Life in the Ante-Bellum South* (rev. & enlarged ed., New York, 1979).

Eugene D. Genovese, *Roll, Jordan, Roll: The World the Slaves Made* (New York, 1980).

Dorothy Sterling ed., *The Trouble They Seen: Black People Tell the Story of Reconstruction* (New York, 1976).

Nell Irvin Painter, *Exodusters: Black Migration to Kansas After Reconstruction* (New York, 1977).

C. Vann Woodward, *The Strange Career of Jim Crow* (3rd rev. ed., New York, 1974).

W. E . B. DuBois, *The Souls of Black Folk* (Chicago, 1903).

Theodore Rosengarten, *All God's Dangers: The Life of Nate Shaw* (New York, 1974).

Richard Wright, *Black Boy* (New York, 1945).

Lawrence W. Levine, *Black Culture and Black Consciousness: Afro-American Folk Thought from Slavery to Freedom* (New York, 1977).

Ralph Ellison, *Invisible Man* (New York, 1952); *Shadow & Act* (New York, 1964).

Robert C. Toll, *Blacking Up: The Minstrel Show in Nineteenth-Century America* (New York, 1974).

Sterling Brown, *The Negro in American Fiction* (Washington, D.C., 1937).

LeRoi Jones, *Blues People: Negro Music in White America* (New York, 1963).

Robert Palmer, *Deep Blues* (New York, 1981).

Patricia A. Turner, *Ceramic Uncles & Celluloid Mammies: Black Images and Their Influence on Culture* (New York, 1994).

Kenneth W. Goins, *Mammy and Uncle Mose: Black Collectibles and American Stereotyping* (Bloomington, 1994).

Marilyn Kerns Foxworth, *Aunt Jemima, Uncle Ben and Rastus: Blacks in Advertising Yesterday, Today, and Tomorrow* (Westport, Conn., 1994).

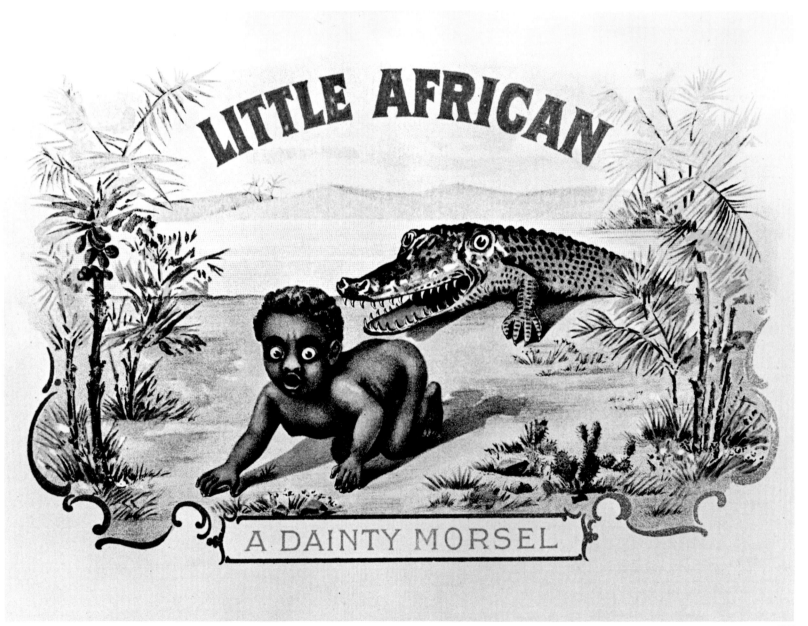

Visual Violence: Stereotypes in American Popular Culture

"No people have felt the sting of the cartoon more than we. Almost in any direction can be seen great wide mouths, thick lips, flat noses, glaring white eyes, and to wind up the thing, there close beside the caricatured is the familiar chicken-coop and out beyond that is the rind of the 'dervastat'd watah million.' "

—John Henry Adams, Jr., in *Voice of the Negro*
(September 1906)

Nearly a century ago, John Henry Adams, Jr., a young illustrator writing for a small periodical in Atlanta expressed the anguish of millions of American men, women, and children. Like his black American brothers and sisters, Adams understood too well the power of the image as a weapon wielded against him by members of a white majority determined to preserve and strengthen their dominance over nonwhites through every means available. In the month that Adams's condemnation of demeaning images of blacks appeared in *Voice of the Negro*, white mobs stormed through Atlanta, attacking black residents. *The Voice* was a particular target of the rioters, who forced it out of Atlanta. It was silenced thereafter.

This exhibition is about stereotypes of black people in America—a persistent set of demeaning generalizations that has created false notions about the essential character of an entire people, denying their humanity as individual beings. The stereotypes are rooted in European beliefs, based on explorers accounts of contact with African people. Europeans regarded Africans as primitive, physically suited to hard work, impervious to suffering or indignity, driven by passions and sensuality while lacking sentiment or sensitivity, without imagination or creativity, and of limited intellect. These beliefs were used to justify the massive Atlantic slave trade, in which ten million Africans were stolen

Theresa Whitener
Doctoral Candidate, U.S. History
University of California, Berkeley

This is an adorable item and it is up for auction. Made of cast iron this bottle opener features a black boy getting nipped on the butt by a hungry Gator. This bottle opener measures 3 $^1/_2$" long and is a real unique piece.

FROM A DESCRIPTION OF AN AUCTION OFFERING ON EBAY,
COLLECTIBLES/CULTURAL/BLACK AMERICANA
CATEGORY, JULY 2000

and sold into a brutal labor system. Notions of blacks' biological inferiority provided ideological scaffolding for America's unique race-based system of slavery, where the slave's status was inherited and usually life-long. After slavery ended, the stereotypes were perpetuated and reinforced by pseudo-scientific theories that crudely applied Darwin's concept of evolution as well as dubious studies of cranial capacity to prove that blacks were less evolved than the white race. No people in American history have been stereotyped as consistently and effectively as African Americans, with devastating effects on America's consciousness and conscience.

These enduring stereotypes have been shaped and strengthened by popular culture. A powerful agent of the stereotypes can be seen in the degrading representations of blacks in ordinary, everyday objects such as those in Janette Faulkner's extensive collection, *Ethnic Notions*. Homemade dolls and cast-iron banks of the early 1800s swelled to an avalanche of cheap toys, decorative and utilitarian household objects, postcards, periodicals, sheet music and other common items that blanketed American life from the second half of the 19th century on. Individually, they were unimpressive, but manufactured cheaply by the millions using new technologies of mass production, they formed an awesome cultural force that infected every niche of American life with their false images of black people. They were not made by nor intended for ultra-racist groups or for southern society only; instead, they pervaded mainstream culture throughout the United States. Their enormous popularity made them highly effective as advertising devices. In their entirety, they projected a stunning array of disparaging caricatures. By the end of the 19th century, these fictitious representations were unavoidable, appearing everywhere one looked, in numbers grossly disproportionate to the visibility of America's black population. Through their unrelenting presence, they poisoned the minds of America.

Cultural objects of such power would be fitting subjects for historical inquiry even if their cruel legacy did not remain with us. Many white Americans have tended to ignore such inquiries, however, regarding them as part of a separate history relevant only to African Americans. But they are mistaken. These objects were manufactured by whites, to benefit, amuse and entertain whites, and the story they tell is not about how African Americans really looked and behaved, but about how American whites imagined and represented them.

Consider the image on a cigar box cover made in 1910. A picture like "Little African, A Dainty Morsel" horrifies and offends most who see it today, and many find it incredible that this once familiar image was regarded as humorous. For decades, pictures of alligators threatening to devour black humans adorned everyday things ranging from this cigar box cover to letter openers, tabletop figurines, and souvenir postcards. This explicit picture should shock and horrify us, for its particular savagery exposes the brutality that underlies most of these objects, often hidden under a deceptive camouflage of humor and "cute" cartoon depictions.

Since these objects were made, American society and culture have changed dramatically. The objects remain what they were, but the meaning that viewers—both black and white—take from them is conditioned by changes in beliefs and attitudes. First exhibited in *Ethnic Notions* eighteen years ago, these old objects and their contemporary meanings deserve a fresh look, for they retain their capacity for harm, and they have much

199

to teach us about ourselves. What do these objects say to us today? Can they promote greater understanding about social injustice? Can they help us see if we've progressed, and where we still need to go? Or does their powerful presence still pose a danger?

Horrors such as "Little African, A Dainty Morsel" are inseparable from the time and circumstances of their creation, and they cannot be understood otherwise. Most of the everyday things here were produced between the 1870s and the 1950s, in the era of America's worst black/white race relations since slavery, as whites systematically stripped blacks of their newly won freedom and rights as citizens. It is no coincidence that these objects were made at the same time as the white majority was fortifying its structure of power and dominance. These images were intentional cultural accomplices to the process of subordinating a people. By virtue of their ability to persuade, and their relentless messages of black inferiority, they complemented the violence and intimidation that rained down on black Americans to deny them entry into the mainstream of American life.

The effectiveness of such objects in conveying false notions of racial inferiority rests largely in the power of the visual image. The visual generalizations in these caricatured images embody messages—stereotypical notions—about the people represented. Through time and repetition, the generalized caricatures form a mental image in the viewer that replaces the authentic image. The messages associated with the mental caricature are projected onto actual people, and become the imagined characteristics of the people themselves. Such mental images are "naturalized": their stereotypical messages, no matter how outrageous or implausible, become tacit assumptions—obvious truths that "go without saying."

Visual depictions are especially persuasive because the visual is real; we more readily believe what we see directly, and we form judgments about people based on visual cues. Unchallenged, the stereotypes implicit in these visual cues became embedded so deeply in American culture that they distorted the identity of an entire people. Messages about blacks were thus transmitted and naturalized in the minds of Americans through these deformed representations. Black people were reduced to stock characters that were portrayed as stupid, or foolish, or vicious, or lazy, or thieving—or happy and eager to serve and entertain their white owners.

The humor in many of the images made violence toward blacks more acceptable by turning it into a source of amusement. If the shuffling Sambo, the rotund Mammy, or the silly little picaninny were mere jokes, then violence inflicted on them need not be taken seriously. That black people were appropriate subjects

for violence, is evident in the many objects that allowed the viewer to visualize blacks subjected to violence: the alligators, the woman with her breast in a wringer, and a common theme—blacks brandishing straight-edge razors and fighting among themselves.

Some objects invited the viewer to actively inflict violence on the black character: toys enabled children to bash a black head, or to hurl darts or balls at figures in the Jolly Darkie Target Game. Adults swung at golf balls perched atop Nigger Head Golf Tees, and extinguished cigarettes into blacks' oversized mouths or between the legs of naked ceramic children.

At the same time that the images promoted violence by rendering it comical, they created a sense of common culture among whites through recognizable visual codes, such as the watermelon and the chicken coop. A symbolic white community, drawn together by its shared condescension toward the amusing, less-human "other," enabled whites throughout America to envision solidarity with other whites, and offered them a common entitlement to the privileges of whiteness. This was of course a social fiction, as it covered up the harsh realities of class and gender inequality. As the resentments of the Civil War still festered, shared chuckles over jokes about black people provided a common ground for northern and southern whites. Editors of northern newspapers who were often highly critical of southern life and customs evidently saw nothing illogical in wrapping an editorial condemning the South for its racial attitudes around a Sunday Supplement offering of sheet music featuring grotesque images of dangerous black brutes wielding razors.

Not all of the objects depicting black people from this period were violent or ugly. Many showed cute little children, plump, kindly Mammies, and smiling

entertainers; and the comfortable affection many Americans felt for Mammy is evident in the popularity of her representations. Their affection did not contradict America's crushing oppression of black people, however. Hundreds of Mammies and Uncle Moses held cookies, offered towels, provided salt and pepper, or grinned in blackface for their owners' entertainment. For decades after Emancipation, these things enabled their white users to experience the psychological satisfaction of holding blacks in a kind of symbolic slavery. Indeed, these gentler images may have been the most damaging of all, for their message was insidious—couched in "harmless" humor that invariably reduced blacks to generalized stereotypes. The black images were intended to amuse, serve and entertain; they were never shown as intelligent, competent, autonomous humans, equal to whites and worthy of respect. Viewers who might squirm at the uglier imagery could easily absorb the subtle deprecations of black people in these deceptively "benign" representations.

The subliminal messages of power and racial subordination embodied in these everyday things is clear in the story of a white woman who grew up in Texas and Oklahoma in the 1920s. She was not racially hostile, but she was conditioned by the attitudes of that time and place, and she accepted the biological inferiority of black people and their segregation from whites as natural. Much later in her life, however, she taught remedial courses to inner-city black students at a community college in Los Angeles, where she gradually came to know them as individuals and to see the daunting racial problems they constantly faced. She was startled one day upon noticing her collection of figurines that had belonged to her mother. They were placed on a shelf together—except for the single black Mammy figure standing alone on the shelf below the others. She had arranged them herself years earlier, without any conscious thought of putting the familiar black character "in its place," but instinctively replicating her implicit understanding of America's racial hierarchy. Although she would never have found alligators chasing black babies attractive or amusing, the servant stereotype embedded in the pleasantly inoffensive Mammy figurine was consistent with a naturalized lifelong notion of black people as servile and inferior.

As we enter a new century, solutions to the tangled psychology of American race relations still elude us, although we are slowly gaining insights into the nature and destructive effects of stereotypes. So why look again at these icons of bigotry? If consciousness has been raised, if whites are becoming more aware of past injustices, is there a compelling reason to revisit such instruments of injustice? After all, the role of these objects and images has undeniably changed over time. They are widely recognized as offensive and hurtful, and rejected as inappropriate. They no longer command center stage in American humor, nor do they unashamedly blanket the cultural landscape in everything from public advertising to private kitchen decorations to the astonishing extent they once did.

Despite this progress, the two-dimensional stereotypes represented in these objects still surface in mainstream culture with disappointing frequency, usually unremarked upon yet highly visible to large segments of the population. It is disturbing that the most prominent appearances are in items intended for the young. Legions of young Pokémon enthusiasts encounter the recently introduced character named Jynx, a malevolent female creature in blackface with bared breasts (one strangely covered by her hand).Other modern imita-

tions of the old stereotypes can seen in the *Star Wars* character Jar Jar Binks, and the black chef character in *South Park*. A new object in this exhibit is "Peaches," a recently produced mask that replaces every trace of the loyal, nurturing Mammy with a grotesquely menacing ape-like grin intended to provide a hilarious Halloween fright. Even if these characters have been created without conscious intent to inflict humiliation, the stereotypes they perpetuate clearly remain naturalized and deeply embedded in American consciousness.

New stereotypes have emerged in the past twenty years. But these urban black stereotypes recycle old notions in new guises, e.g., the "welfare queen" (black people are still lazy and black women are rarely attractive); the "gang banger" (black males are still dangerous); and the "sports superstar" (blacks are still best suited for physical, rather than intellectual activity). These are the most commonly held perceptions of blacks among white Americans today. The old notions continue to foster contemporary outrages such as racial profiling and the use of images of black criminals in political advertising. Considering the alarming emergence of new stereotypes, it becomes clear that viewing images from the past helps us understand how such ideas and attitudes are naturalized through such cultural messages. It also reveals the persistence of their contemporary manifestations. The stereotypical representations—of blacks, other people of color and cultures, women, gays, and others who are somehow different from the self-defined mainstream "normal" American—continue to infect our culture and quietly sustain the inequities and injustices inherent in an entrenched social hierarchy.

Exposure to these images supports efforts to unveil the hidden wrongs of American history. To see that members of a broad society were amused by a cigar-box cover that depicted a tiny black baby as an alligator's "dainty morsel," or that they gave their children toys with which to inflict play-violence on unfeeling metal cartoon "niggers," is the beginning of an epiphany. It is to begin to grasp how vast numbers of ordinary people could also have perpetrated—through amused negligence if not active participation—decades of violence and oppression upon the group so routinely and visibly brutalized in popular culture. To conceal these because they horrify and repulse or instill guilt or fear is to accommodate powerful factions who benefit from the preservation of a mythical version of history and who are unwilling to confront injustices that have remained hidden (to whites at least) for decades.

Likewise, the less violent images have not released their grip on the American consciousness, even among those who have morally rejected violence against people unlike themselves. We need to see these objects, not as the earlier viewers who took these fictitious caricatures as truthful representations, but to understand how easily caricature can displace truth. Nor must we regard them as dead relics. We must examine them with a critical eye, recognizing them as significant historical artifacts. They offer an important lesson about the unhealed wounds of America's tragic racial history, and they are living reminders of the power of the symbolic image and the stereotypes that have caused such misery.

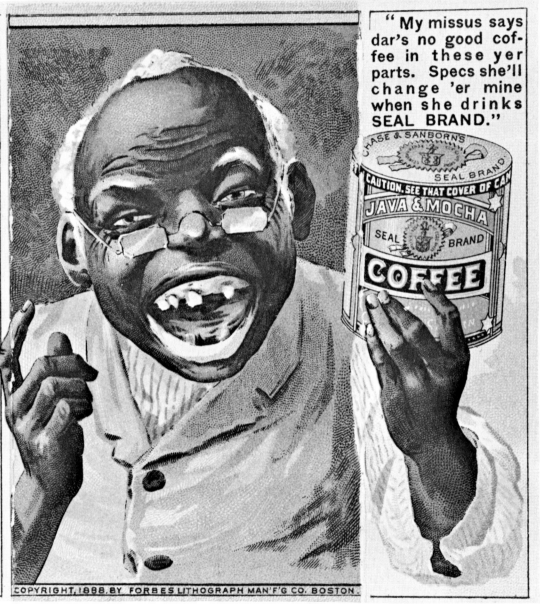
137

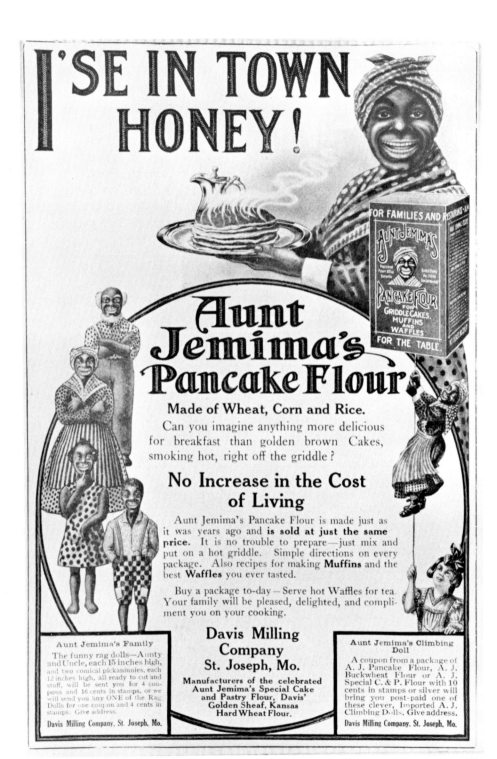

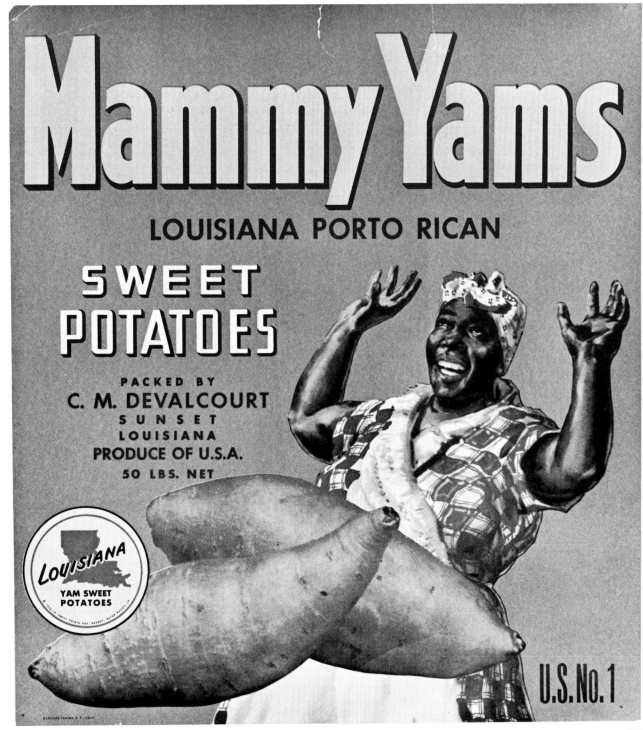

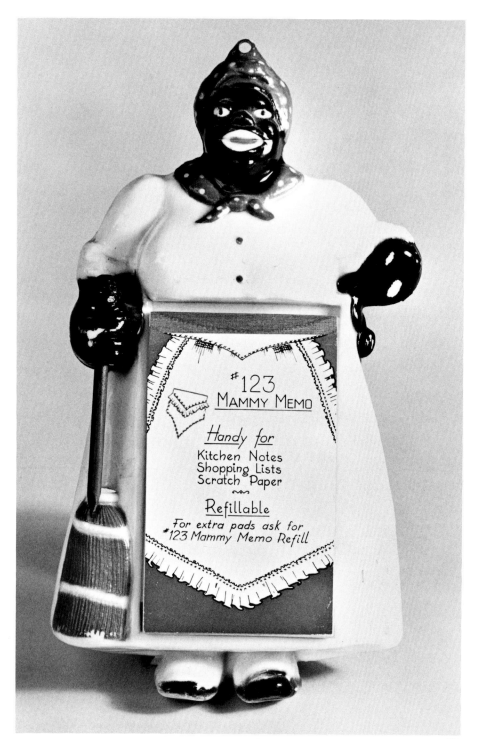

WE NEEDS

?

- APPLES
- BACON
- BREAD
- BUTTER
- CEREAL
- COFFEE
- CRACKERS
- EGGS
- FLOUR
- LARD
- LEMONS
- LETTUCE

- MATCHES
- MEAT
- MILK
- ONIONS
- ORANGES
- PEPPER
- POTATOES
- RICE
- SALT
- SUGAR
- TEA
- TOMATOES

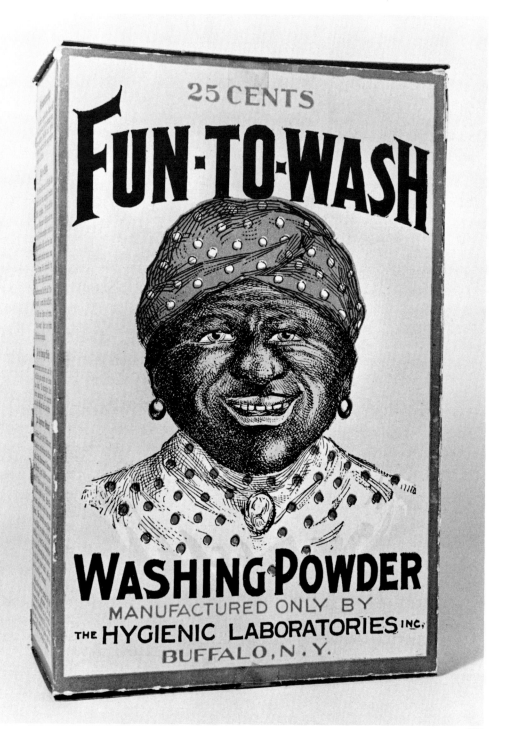

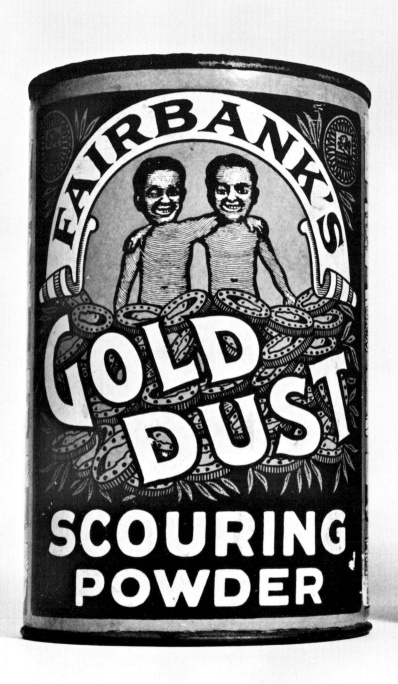
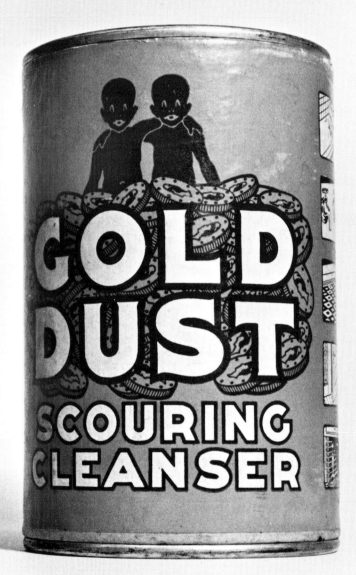

194. 195

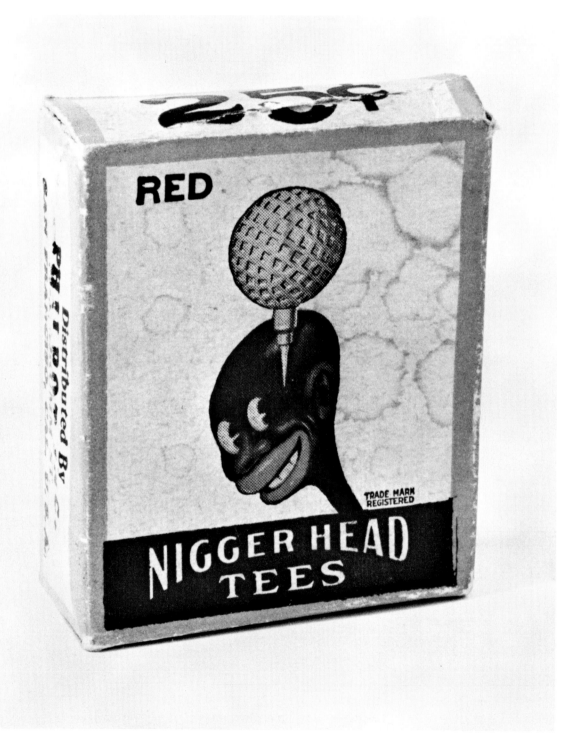

71

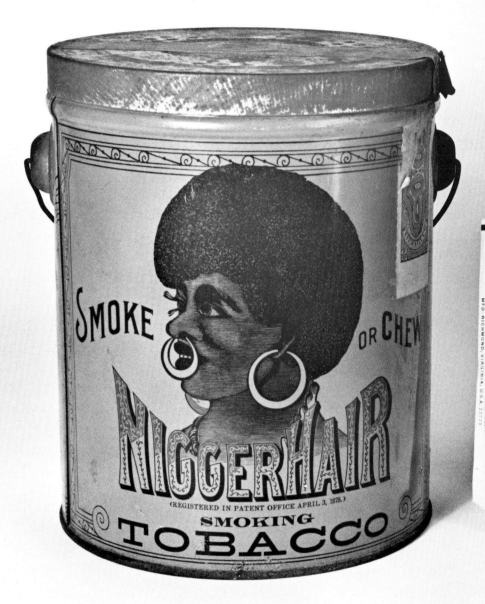

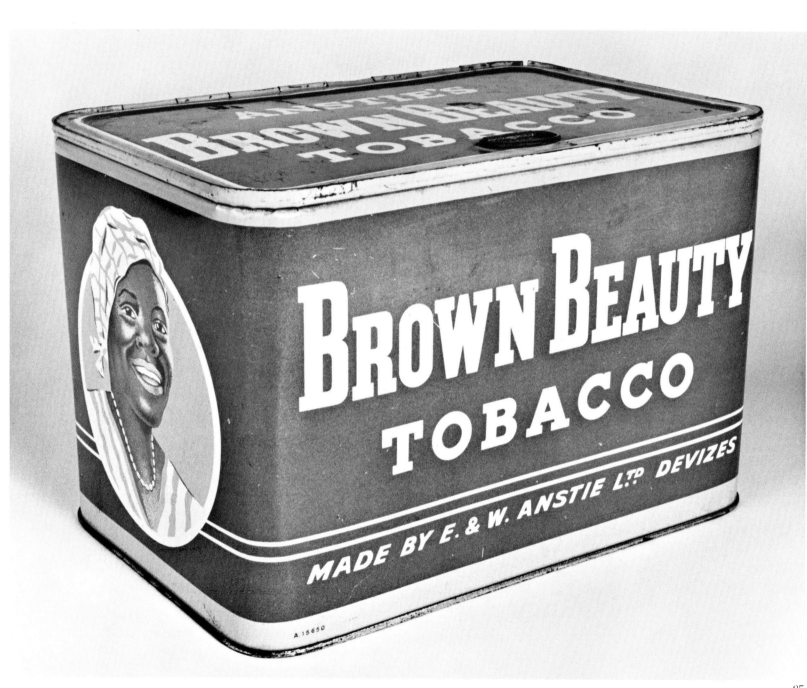

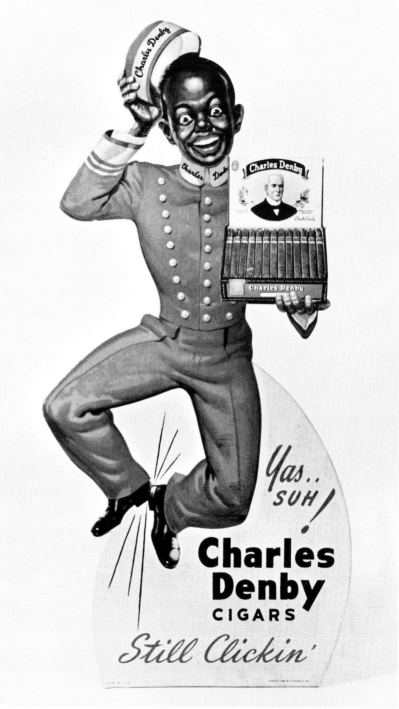

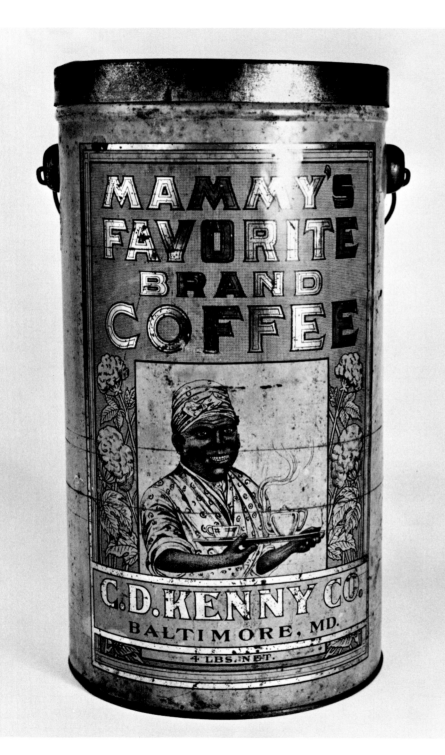

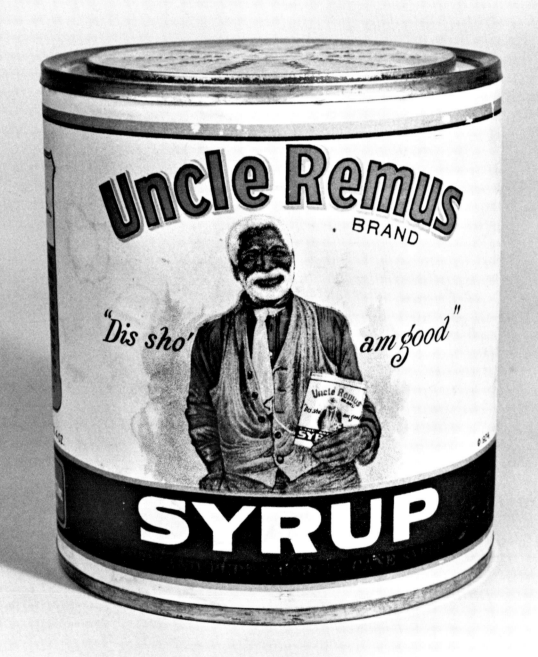

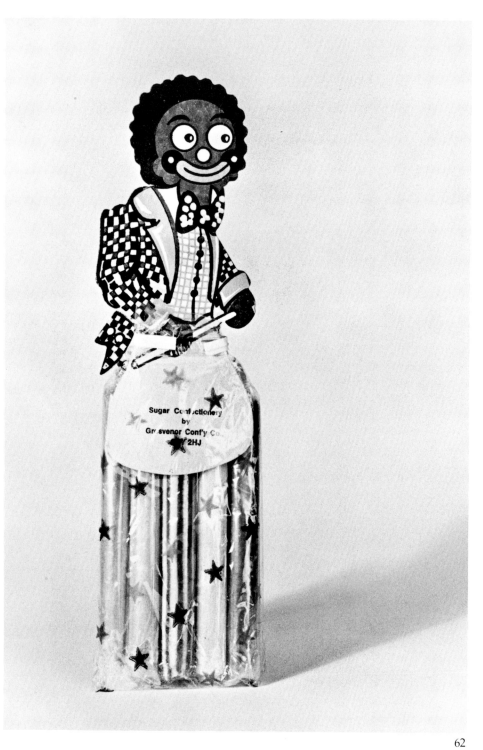

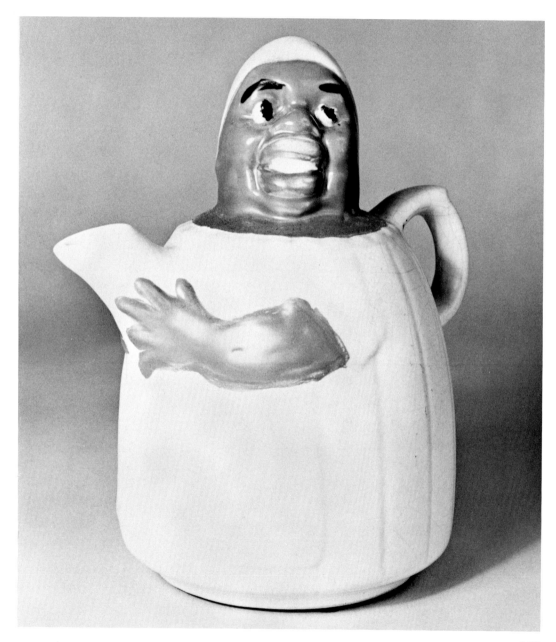

140

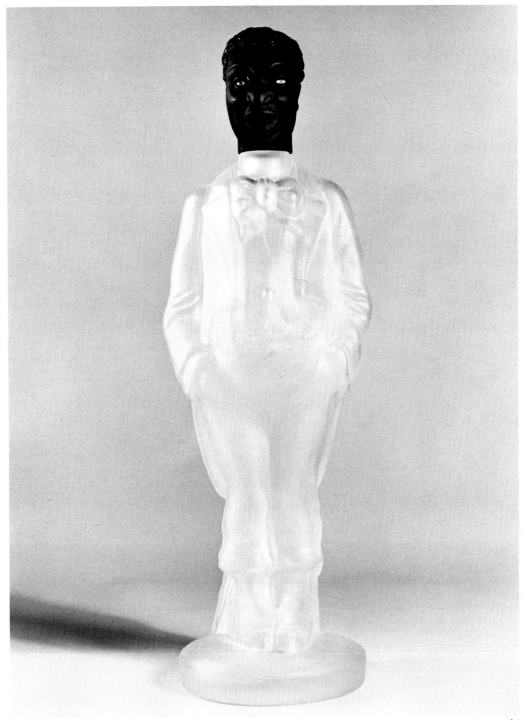

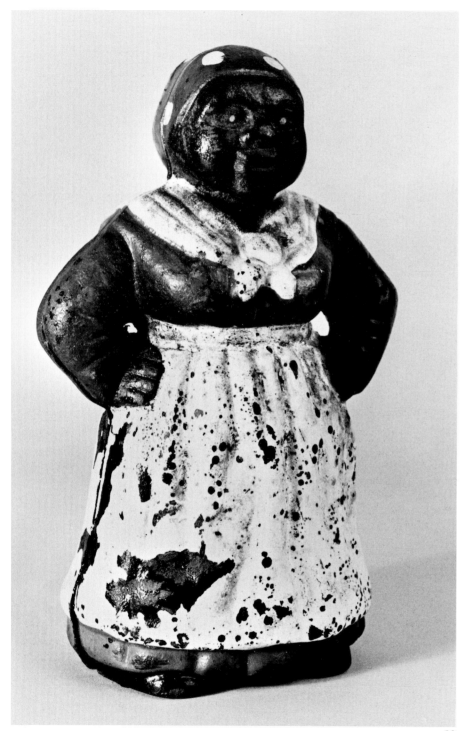

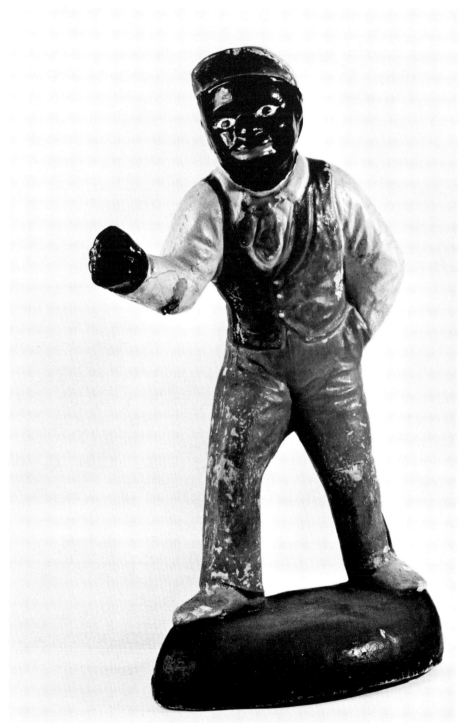

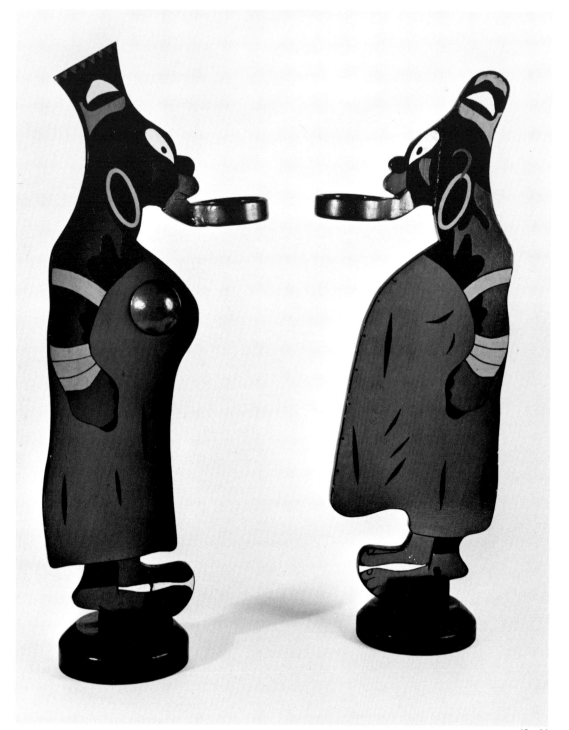

43, 44

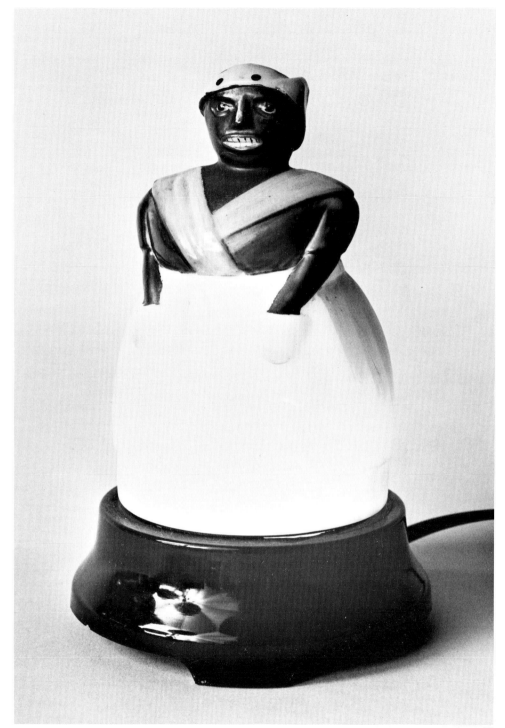

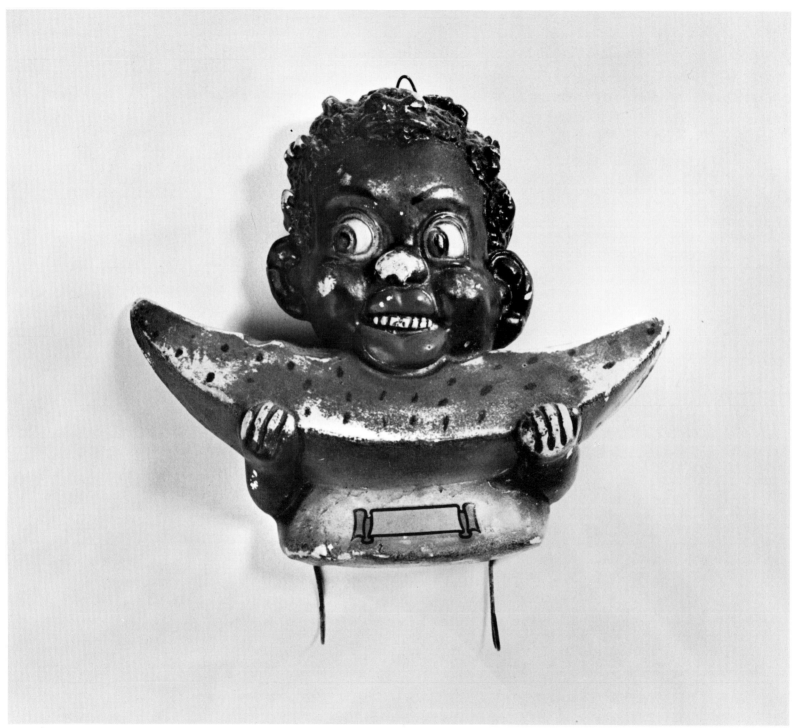

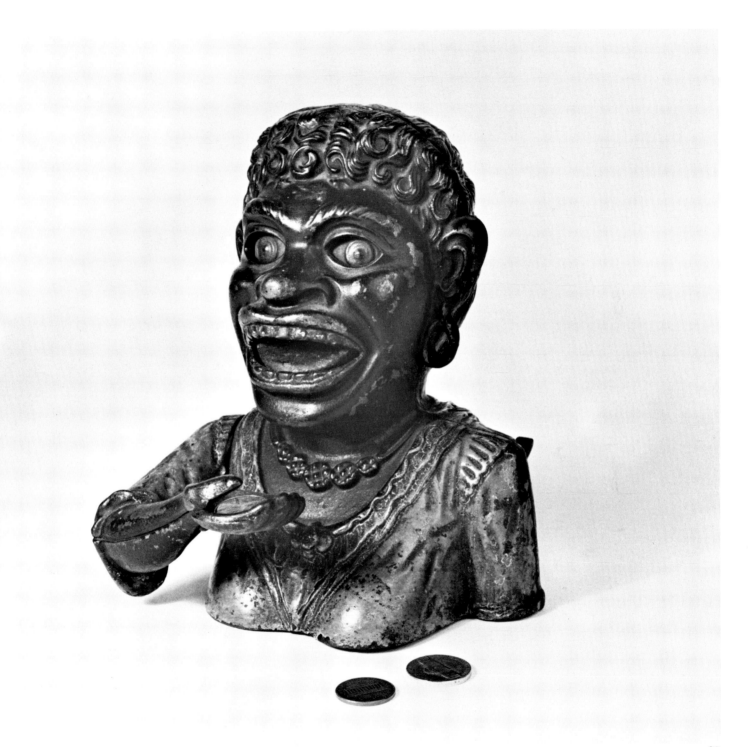

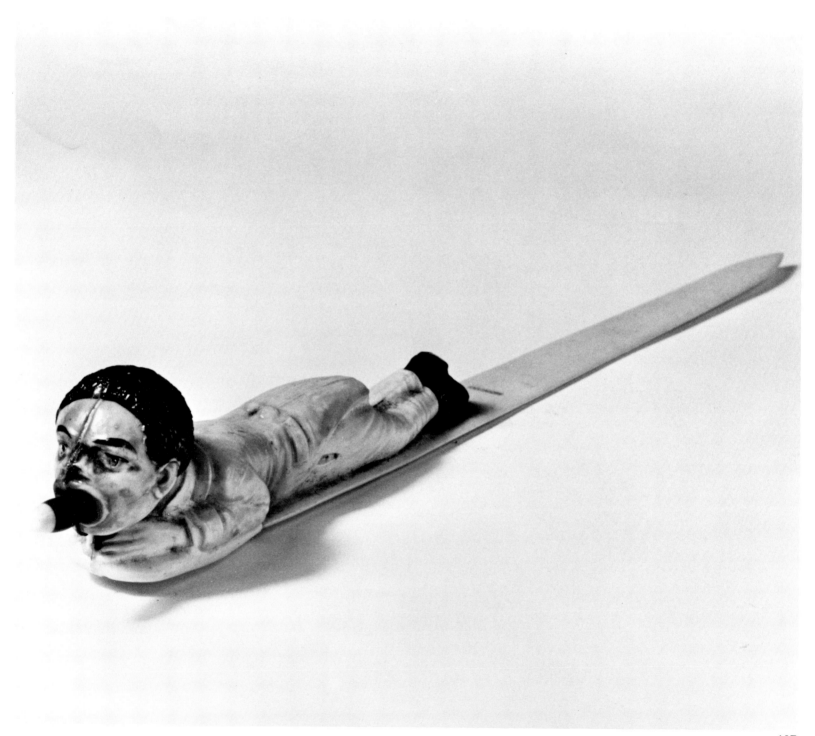

197

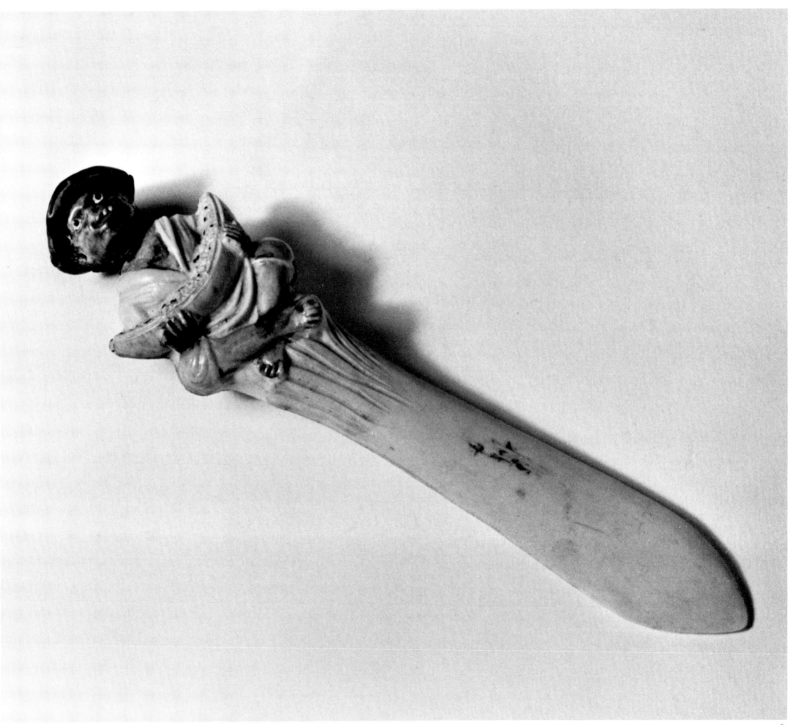

2

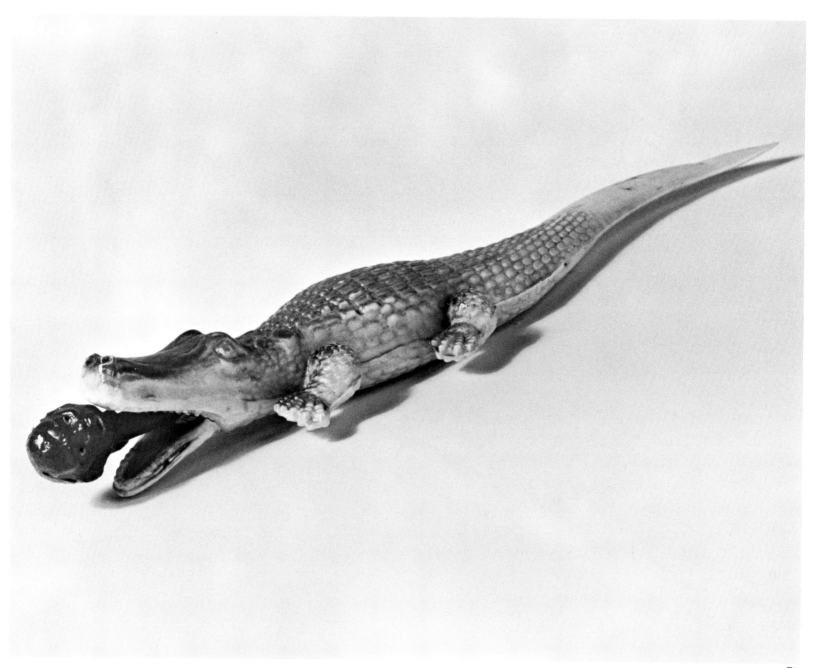

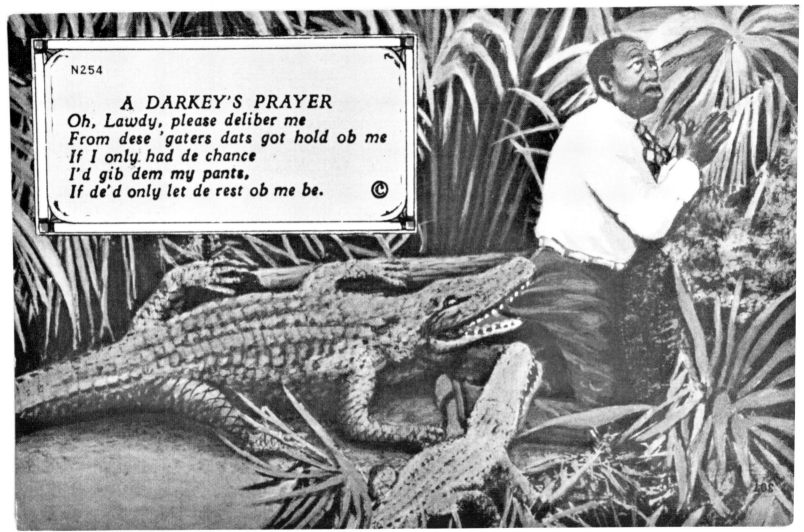

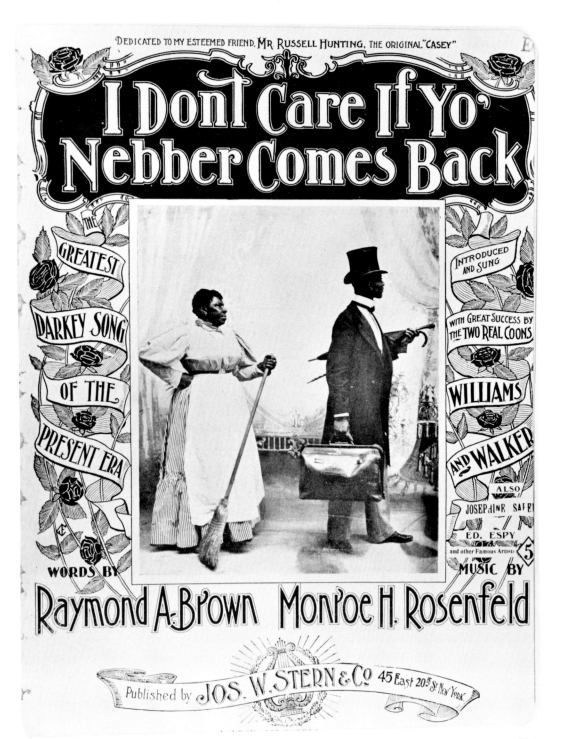

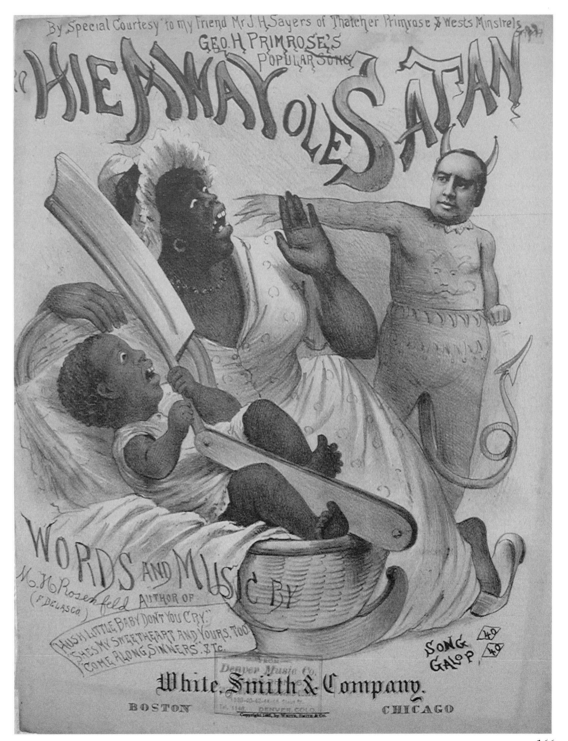

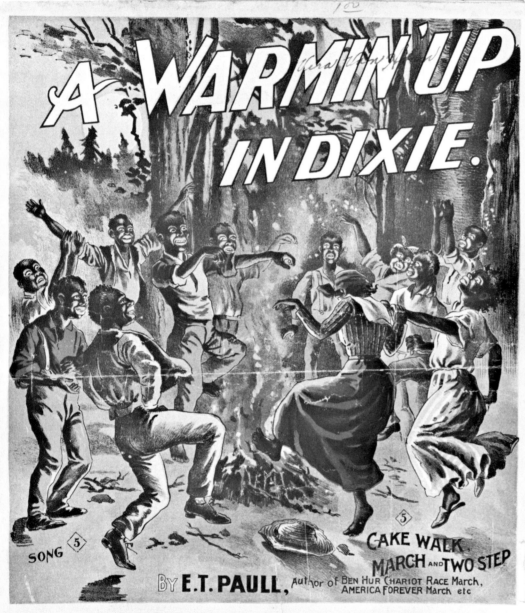

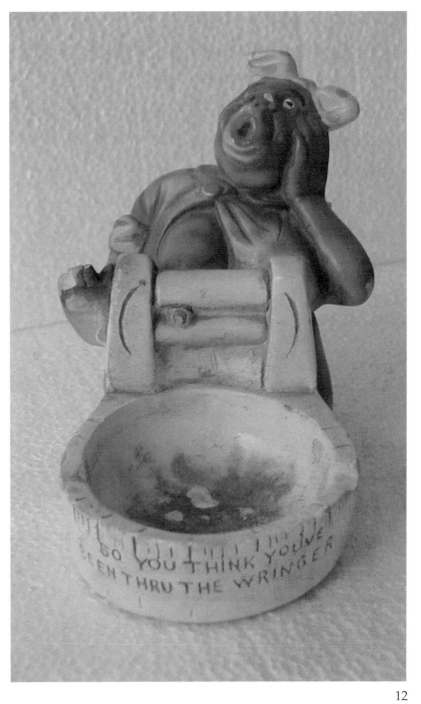

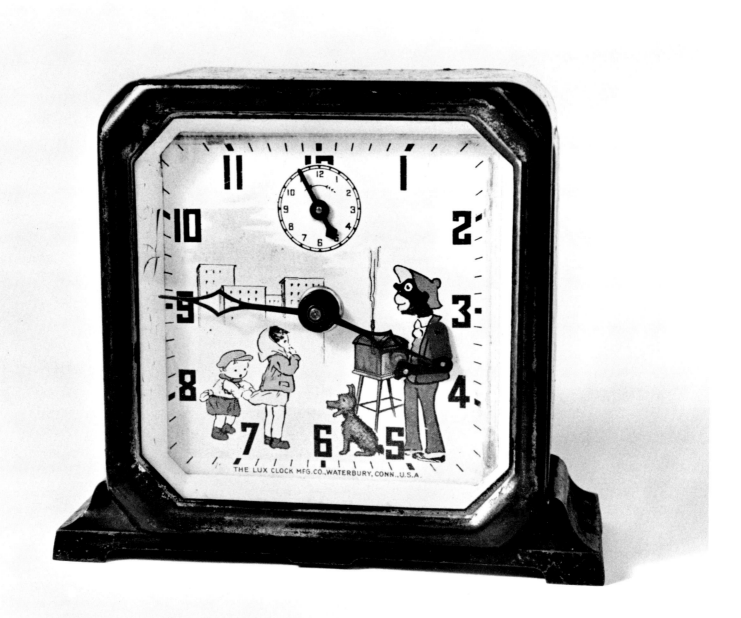

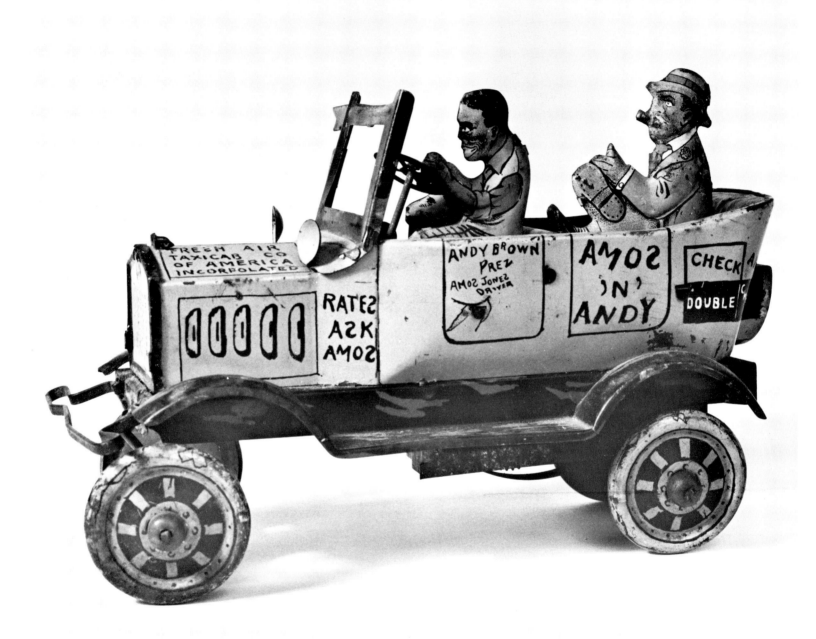

107

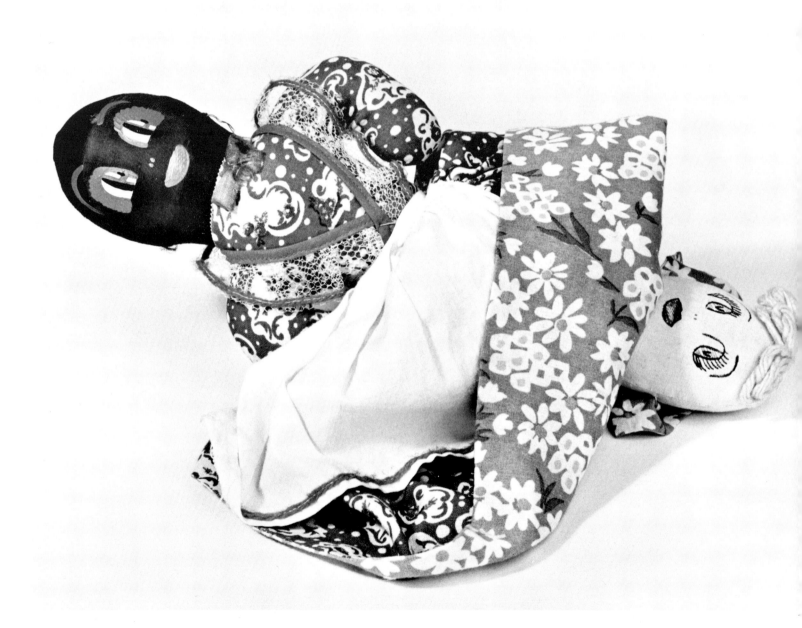

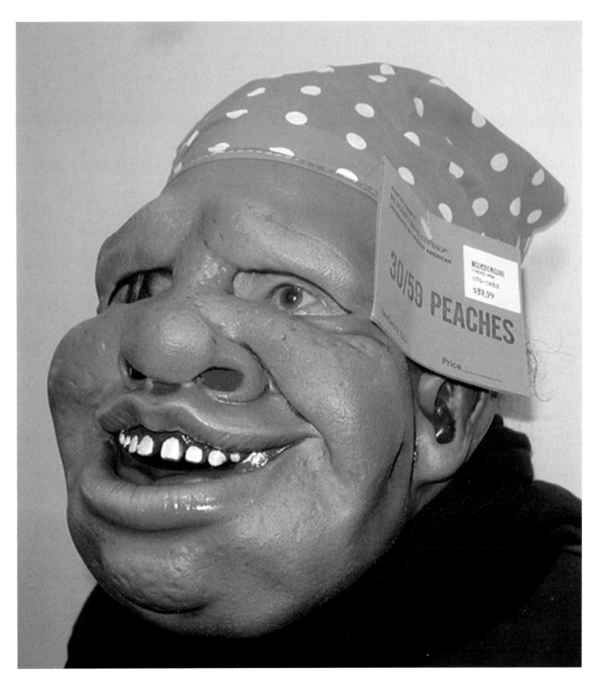

Catalog

All dimensions are in inches.

1. Child's Game "Snake Eyes"
cardboard, 1920s. These cards are from a game similar to the game of "Old Maid." ($11 \times 7^{1}/_{2} \times 1^{1}/_{2}$)

2. Letter Opener
biskoline, early 1900s. ($11^{1}/_{2} \times {}^{3}/_{4} \times 1^{1}/_{2}$)

3. Pinball Game
wood, early 1900s, made in Ingleside, California. This game is called "Jazzbo." ($13^{1}/_{2} \times 23 \times 1^{1}/_{2}$)

4. Pepper Shaker
ceramic, early 1940s. This item was made as a souvenir and sold in Irvine, California. ($5 \times 2^{1}/_{4} \times 2^{5}/_{8}$)

5. Syrup Container
tin, 1924. Produced by Robinson Syrup Company, Cairo, Georgia. ($4^{1}/_{2} \times 4$ d.)

6. Tobacco Jar
china, late 1800s, made in England. ($4 \times 4 \times 4^{1}/_{2}$)

7. Plantation Alphabet Book
paper, 1900. The book was published by Earnest Nister and E. P. Hutton Company, New York, and printed in Bavaria. ($9^{1}/_{4} \times 11^{1}/_{4}$) *The item on display is a facsimile of the original.*

8. Advertising Standup
cardboard, 1940s. Produced by Charles Denby Cigar Company. ($13^{1}/_{4} \times 6^{1}/_{2}$)

9. Pamphlet
paper, 1853, England. The pamphlet is titled, "The Nigger Question" by Thomas Carlyle. ($4^{1}/_{2} \times 7$)

10. Folk Art Puppet
wood, early 1800s, handmade. Origin unknown. ($11 \times 5^{3}/_{4} \times 5^{3}/_{4}$)

11. Easter Egg
papier-mâché, Victorian era, European. ($4^{1}/_{2} \times 5$ d.)

12. Ashtray
chalk, 1953. "So you think you've been through the wringer?" produced by Plastic Arts, a novelty company in the Midwest. ($5^{3}/_{4} \times 5 \times 4$)

13. Salt and Pepper Shaker
bisque, early 1900s, made in Belgium. ($3 \times 1^{1}/_{2} \times 2^{1}/_{4}$)

14. Ashtray
cast iron, mid-1800s, made in the U.S.A. ($4 \times 3 \times 4$)

15. Hamburger Advertisement
paper, 1990s, France. From a fast food restaurant. ($4^{1}/_{2} \times 5^{1}/_{4}$)

16. Plate
ceramic, 1940s. "The Coon Chicken Inn" was a restaurant chain in Oregon, Washington and Utah. (9 d.)

17. Toothpick Holder
metal alloy, 1940s. ($2^{1}/_{2} \times 2^{1}/_{2} \times 1$) *See 16 above.*

18, 19, 20. Souvenir Dolls
pecan nuts, wood and cotton, 1920s, made in Appalachia and sold in Memphis, Tennessee. (Each approx. $7\,^1/_2 \times 4 \times 1\,^1/_2$)

21. Ashtray
metal and metal alloy, 1949, made in occupied Japan. Such figures are known as "nodders," because of the nodding head. ($4\,^3/_4 \times 4\,^3/_8 \times 3\,^3/_4$)

22, 23, 24. Set of Cup Holders
chalk, 1940, U.S.A. These are examples of the frequent use of watermelon as a motif associated with African Americans. ($5 \times 6 \times 1\,^1/_4$)

25. Souvenir Spoon
sterling silver, light gold wash, 1900s, made in the U.S.A. ($4 \times\,^7/_8 \times\,^3/_8$)

26. Salt Shaker
plaster of Paris, early 1900s, maker unknown, typical of American-made circus giveaways. ($3\,^3/_4 \times 3 \times 2$)

27, 28. Set of Bookend Planters
china, pre–WW II, made in Japan by the Taieo Company. ($4 \times 4\,^1/_2 \times 3$)

29, 30. Salt and Pepper Shakers
chalk, 1930, maker unknown. ($2\,^1/_4 \times 2\,^1/_4 \times 1\,^1/_2$)

31. Pull Toy
wood and metal, 1910. "Sambo Special" maker unknown. ($12 \times 7\,^1/_4 \times 15$)

32. Advertisement
paper, 1880s. The artist is unknown, but this is a familiar advertisement for soap, produced by the Sapolio Soap Company, U.S.A. ($16 \times 13\,^1/_4$)

33. Bank
cast iron, 1911. The "Dinah" bank, was made by John Harper & Company, Ltd., England. The eyes roll when a coin is placed in the mouth and the lever on the shoulder is pressed. ($6\,^1/_4 \times 5\,^1/_4 \times 5$)

34. Bank
cast iron, c. 1882. Known as the "Jolly Nigger," this bank was made by the J. C. Stevens Company. Operates the same as 33 above. ($6 \times 5\,^1/_2 \times 6$)

35. Bank
cast iron, late 1880s, "Young Nigger," made by the J. C. Stevens Company, related to 34 above, but not mechanical. ($4\,^1/_2 \times 3 \times 3\,^1/_2$)

36. Child's Puzzle Game
cardboard, isinglass and glass beads, mid-1800s. Advertising giveaway by the W. D. Plumbing Company, Binghamton, N.Y. ($2\,^1/_2$ d. $\times\,^1/_4$)

37. Advertising Card
cardboard, 1930, made in U.S.A., and distributed by a drugstore to promote the sale of a medication, Kendall's Spavin Cure. ($6\,^1/_2 \times 3\,^1/_2$)

38. Tobacco Jar
ceramic, early 1920s, made in France. ($4\,^1/_2 \times 2\,^3/_4 \times 3$)

39. Toothpaste
paper, metal and plastic, contemporary. Manufactured by an English, Taiwan-based company, Hawley and Hazel. Marketed in Taiwan, Japan, the Middle East. ($7 \times 1\,^1/_2 \times 1\,^3/_8$)

40. Game
cardboard and wood, early 1900s. "The Game of Sambo," made by Parker Brothers, part of a child's standup target game. (Toy: $10 \times 5\,^1/_4 \times 3\,^3/_4$; Box: $6 \times 10\,^1/_2 \times 2$)

41. Swizzle Stick
glass, 1930s, made in Germany. ($4\,^3/_4 \times\,^3/_4 \times\,^3/_4$)

42. Night Light
bakelite and glass, late 1920s, made in the U.S.A. by an unknown manufacturer. ($7 \times 4\,^5/_8$ d.)

43, 44. Smoking Stands
wood, Art Deco period, U.S.A., maker unknown. The distortion is patterned after an African tribe popularized by P. T. Barnum and called by him the *Ubangi*. (Each: $35 \times 12 \times 4\,^1/_2$)

45. Erotic Toy
plastic, 1976. Made in Taiwan, this is called "The Black Power Toy." When the head is pressed down, a penis erects. ($7\,^1/_4 \times 2\,^1/_4 \times 1\,^3/_4$)

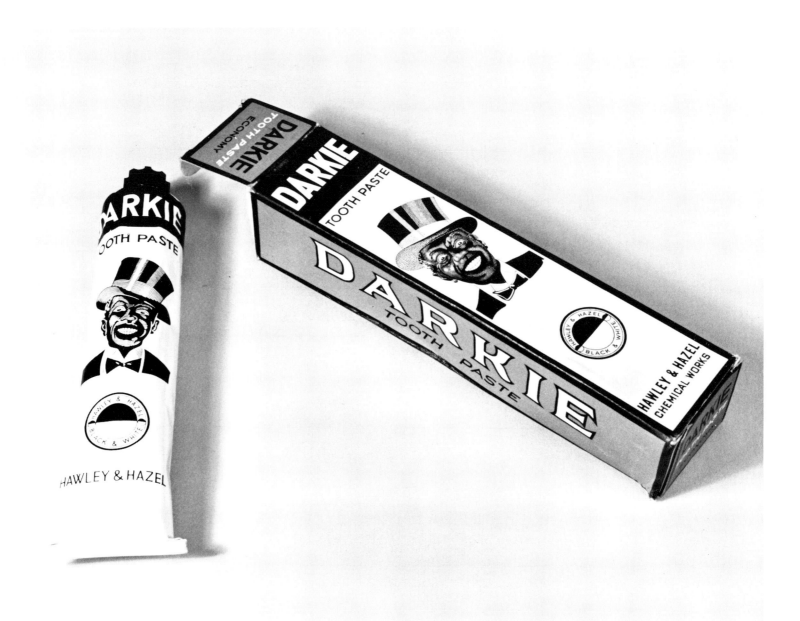

46, 47. Salt Shakers
ceramic, 1979. These were designed by Bill Dilli, of Hawaii. (Each: 6 1/4 x 1 3/4 x 2)

48. Erotic Toy
isinglass and rubber, 1930s. The body gyrates when the crank is turned. (2 1/4 d. x 3/8)

49. Tobacco Tin
tin, 1910. Manufactured by the American Tobacco Company until the 1950s, when the NAACP pressured the manufacturer to change its logo and name. Related to 50, below. (6 5/8 x 5 1/2 d.)

50. Tobacco Package
paper, c. 1957. This was the new packaging and logo devised by the American Tobacco Company. *See 49, above.* (5 1/4 x 3 1/2)

51. Household Thermometer
chalk, 1930. Circus giveaway produced by Malty Properties, U.S.A. (6 1/2 x 4 3/8 x 1)

52. Squeeze Toy
rubber, 1920s. Maker is unknown. (9 1/2 x 4 1/4 x 3 1/2)

53, 54. Two Greeting Cards
paper, late 1920s and early 1940s. The earlier card is by the American Greeting Card Company, and the later card is by Hallmark Cards. (3 7/8 x 4 3/4 and 4 x 5 1/4)

later card is by Hallmark Cards. (3 $^{7}/_{8}$ x 4 $^{3}/_{4}$ and 4 x 5 $^{1}/_{4}$)

55. Photograph
paper, 1891. Signed by McCrary Branson, Knoxville, and entitled: "Last One Is a Nigger." (19 $^{1}/_{2}$ x 7)

56. Aunt Jemima Cookie Jar
ceramic, 1990s. Artist Carrie Mae Weems re-molded it without color. (12 x 7 $^{1}/_{2}$ d.)

57. Hose Holder
wood, rubber and metal, 1949. Called "Sprinkling Sambo," this item was manufactured by the Firestone Tire Company. (32 x 11 $^{1}/_{4}$ x 6 $^{1}/_{2}$)

58. Souvenir
cotton and bisque, 1939. This was produced by the Joseph Hollander Novelty Company, Baton Rouge, Louisiana. (2 $^{3}/_{4}$ x 1 $^{1}/_{2}$ x 1 $^{1}/_{2}$)

59. Souvenir
styrofoam and clay, 1967, produced in New Orleans. (2 $^{3}/_{4}$ x 3 x 1 $^{3}/_{4}$)

60. South Park Savings Bank
plastic, 1998, made in China for Comedy Central. Manufactured and licensed by Street Players Holding Corporation, Los Angeles. (11 $^{1}/_{2}$ x 6 x 5)

61. Bric-a-Brac
bisque, 1800s, England. Sociopolitical commentary on the English objection to tariffs imposed on them for the welfare of blacks coming from the West Indies. (3 $^{3}/_{4}$ x 1 $^{3}/_{4}$ x 2)

62. Candy
paper and candy, 1981. Made in England, shows the persistence of Golliwog imagery. (9 $^{1}/_{4}$ x 2 $^{1}/_{2}$ x $^{1}/_{2}$)

63, 64, 65, 66. Golliwog Perfume Bottles
glass, 1910. These were made by de Viary Company, France. The hair is made of seal skin. (6 x 3 $^{3}/_{4}$ x 2 $^{3}/_{4}$ and 3 x 1 $^{7}/_{8}$ x 1 $^{3}/_{8}$)

67. Cajun Popcorn
printed paper bag and popcorn, 1970s, made in Baton Rouge, Louisiana. (6 $^{1}/_{4}$ x 6 $^{1}/_{4}$ x 1 $^{5}/_{8}$)

68. Dart Board
cardboard, early 1900s, maker unknown. Designer E. Higginson, made in the U.S.A. (17 $^{1}/_{2}$ x 24)

69. Pokémon Characters
plastic, 1998, China. The character below is called *Jynx*. (7 x 3 $^{3}/_{4}$ x 1 $^{1}/_{4}$)

70. Letter Opener
biskoline, early 1900s, Germany. The removable head is the top of a pencil. Biskoline is an early plastic, less brittle and flammable than celluloid. (7 $^{3}/_{4}$ x 1 $^{1}/_{2}$ x $^{1}/_{2}$)

71. "Nigger Head" Golf Tees
paper, 1920s, U.S.A. (2 x 2 $^{1}/_{2}$ x $^{7}/_{8}$)

This important piece was in the 1982 exhibit, but not included in this exhibit.

72. Post Card
paper, 1914, Cochrane Company, Platka, Fla. The caption reads, "Alligator Bait." (3 $^{1}/_{2}$ x 5 $^{1}/_{2}$)

73. Dar'kie Mints
paper wrapped candy, 1996, giveaways aboard Air China (2 $^{1}/_{4}$ x $^{3}/_{4}$ d.)

74. String Holder
papier mâché, 1941. Made by Wenden Crafts Company, New York City, from an early form of *papier mâché* called "chewed paper," a string is pulled through the opening of "Mammy's" apron. (7 x 4 $^{3}/_{4}$ x 3 $^{1}/_{2}$)

75. Dinner Bell
metal, wood and cloth, 1941. This was a souvenir made in Dallas, Texas. (4 $^{1}/_{2}$ x 2 x 2)

76. Coffee Can
tin, early 1900s. "Mammy's Brand," was produced in Baltimore, Maryland by D. D. Kenny Company. (10 $^{1}/_{2}$ x 6)

77. Cracker Jar
ceramic, 1930s. This Mammy cracker jar was made in Japan. (9 $^{1}/_{2}$ x 7 x 5 $^{1}/_{2}$)

78. Advertising Card
paper, 1910. An early depiction of

79. Advertising Button
metal, 1940. There is a marked change in the image between this and the preceding item. (2 $^1/_4$ x 1 $^1/_4$)

80. Bank
cast iron, 1900s, U.S.A. (5 $^1/_4$ x 5 x 3)

81. Bank
cast iron, 1930s, U.S.A.
(8 $^1/_2$ x 5 x 4 $^1/_4$)

82. Souvenir Salt Shaker
plastic, early 1900s. F. & F. Noldene Works, Dayton, Ohio, sold the logo to Luzianne Company. The "Luzianne Mammy" is associated with Luzianne Chicory Manufacturers and is still sold. (5 $^1/_4$ x 2 $^5/_8$ x 2)

83. Cannibal Drain Pipe Cleaner
metal, 1950s, made in U.S.A.
(4 $^1/_2$ x 3 d.)

84. Coffee Can
tin, 1928, William M. Reilly & Co., Inc., New Orleans and Baltimore.
(7 $^1/_4$ x 6 d.)

85. Tobacco Container
tin, 1930s, E. & W. Anstie, Ltd., Devizes, France. (8 $^1/_4$ x 5 $^5/_8$ x 5 $^3/_4$)

86. Troll
bisque, early 1900s, Germany. (5 $^3/_4$ x 3 $^3/_4$ x 2 $^1/_2$)

87. Cup Holder
wood, early 1940s, U.S.A. This was handmade for home use. (5 $^3/_4$ x 10)

88. Doll
cloth with cotton stuffing, 1910. Davis Milling Company, original owner of the Aunt Jemima Pancake Company. (14 $^3/_4$ x 7 x 2)

89. Memo List Holder
wood, 1940s. (11 x 7 x $^3/_8$)

90. Cookie Jar
pottery, 1933, McCoy Pottery Company, Roseville, Ohio. Nelson McCoy Sanitary and Stoneware Company was founded by Nelson McCoy, son of J. W. McCoy, a well-known 19th-century potter. This is an example of a Mammy Cookie Jar.
(10 $^1/_2$ x 7 $^1/_2$ x 1)

91. Memo Pad Holder
Plastic, 1930s. The "Mammy Memo Holder" was manufactured in the U.S.A. The pencil in the right hand was made in Germany in the early 1900s and has the head of a black male. This type of pencil, which does not belong with this piece, was commonly used in conjunction with alligator letter openers.
See item 70.
(10 $^1/_4$ x 5 $^1/_2$ x 1)

92. The Canapé Book
1934, Appleton Century Co., New York and London.
(7 $^1/_4$ x 5 $^1/_8$ x $^1/_2$)

93. Hand Purse Mirror
plastic, tin and glass, 1980. A reproduction of an early Aunt Jemima Breakfast Club Button distributed by the Ralston Purina Company in the 1940s. This image is currently a popular collectible. (3 d.)

94. Doorstop
cast iron, late 1800s, U.S.A.
(6 $^3/_4$ x 13 x 2 $^5/_8$)

95. Salt & Pepper Shakers
ceramic, 1950s. These are homemade copies of the "Aunt Jemima" and "Uncle Mose" pepper shaker. *See 96, below.* (each 5 x 2 $^1/_2$ x 1 $^1/_2$)

96, 97. Salt & Pepper Shakers
celluloid, 1940s. Made by F. & F. Windyworks, Ohio, these were a premium giveaway offered by Ralston Purina Company in exchange for boxtops from Aunt Jemima Pancake Mix boxes.
(each 5 $^1/_4$ x 2 $^1/_2$ x 2)

98. Figurine
wax, mid-1800s. This represents a black laborer. Made by the famous Vargas family of New Orleans, makers of wax dolls. (7 x 3 x 2 $^5/_8$)

99, 100, 101. Coffee Set
Meissen Ware, 1800s. German made, this set depicts the exotic black servant. (7 x 6 x 3 $^1/_2$, 10 $^3/_4$ d., and 3 $^3/_4$ x 6 x 4 $^1/_4$)

105

102. Alligator and Child
bronze, early 1950s. Known as "Vienna Bronze," this is based on gold weights from Africa. ($2 \frac{1}{2} \times 5 \times 2 \frac{2}{3}$)

103, 104. Masks
latex and cloth, late 1990s, **"Plain Brown Rapper"** and "Peaches" made by Be Something Studio, Chicago. Purchased in Berkeley, Calif., as Halloween masks. ($8 \times 10 \times 5$)

105. Card Stand
wood and brass, 1920, England. This item was commonly used to hold calling cards. ($36 \times 13 \times 7 \frac{1}{2}$)

106. Bridge Talleys
paper, 1930. Depicting Amos 'n' Andy, these were made by A. Davis Company, U.S.A. ($6 \times 7 \frac{1}{2} \times \frac{7}{8}$)

107. Child's Toy
tin, 1930s. Made by Louis Marx Company, this windup toy represents Amos 'n' Andy's Fresh Air Taxicab. ($5 \times 4 \times 8$)

108. Child's Toy
plastic, 1980s. Manufactured in Japan, this comes in a box picturing a white porter on the outside. ($3 \frac{3}{4} \times 2 \frac{1}{2} \times 1 \frac{3}{4}$)

109. Toy
tin, 1930. Called "Ham and Sam," this was made by Strauss Mechanical Toy Company, U.S.A. ($7 \frac{1}{4} \times 7 \frac{1}{4} \times 5 \frac{1}{2}$)

110. Clock
cast iron, 1847, Bradley & Hubbard Company, U.S.A. The banjo player's eyes blink. ($15 \frac{3}{4} \times 10 \times 4 \frac{3}{4}$)

111. Children's Clock
metal and glass, 1910, Westbury Company, U.S.A., depicts a black peanut-vendor. ($5 \frac{1}{2} \times 5 \frac{1}{2} \times 2$)

112. Doll
cotton cloth and stuffing, 1914. This representation of the "Cream of Wheat Man" was a giveaway in exchange for box tops. *See item 119, below.* ($18 \times 6 \times 4 \frac{1}{2}$)

113. Souvenir Spoon
gold wash and sterling silver, 1897. Made by Gorham Sterling, U.S.A., the enameled bowl depicts a watermelon. The boy at the top, darkened with silver, has a white enameled collar. The handle date is October 2, 1897. ($4 \frac{1}{2} \times \frac{3}{4} \times \frac{3}{8}$)

114. Stereoscopic Viewing Card
cardboard and paper, 1894, made by Underwood and Underwood and distributed internationally. The title, "Blackberries and Milk," is translated into six languages on the back including English, French, German, Spanish and Russian. ($3 \frac{1}{2} \times 7$)

115. Sheet Music
paper, 1900. "A Warmin' Up in Dixie," published by E. T. Paul Music Company, New York. ($10 \frac{1}{2} \times 14$)

116. Toy, "Le Negre Vorace"
reinforced paper, 1984, Germany.
(4 x 4 x 1 ¹/₈)

117. Toy
tin, 1921. This toy, also by Strauss Toy Company, is called "Jazzbo-Jim."
(9 ¹/₂ x 3 ¹/₂ x 5 ¹/₂)

118. Candy "Conguitos"
candy, paper, 1990, Spain. (5 x 2 ¹/₂)

119. Puppet
rubber and cloth, 1930s, American.
(12 x 8 x 3 ¹/₂)

120. Sheet Music
paper, 1896. "Don't Love Nobody," published by Howley, Haviland & Company. (10 ¹/₂ x 14)

121. Advertisement
paper, 1915, U.S.A., Galen J. Perret. Although the Cream of Wheat Man's image was never distorted, in advertisements blacks around him were regularly caricatured. (10 x 14)

122. Sheet Music
paper, 1896. "Bully Song," *San Francisco Examiner* supplement.
(12 ¹/₂ x 9 ¹/₄)

123. Songbook
paper, 1932, U.S.A. "Bert Williams' Famous Song Hits." George Walker and Ada Overton Walker are depicted without makeup, while Bert Williams is in blackface. (9 x 12)

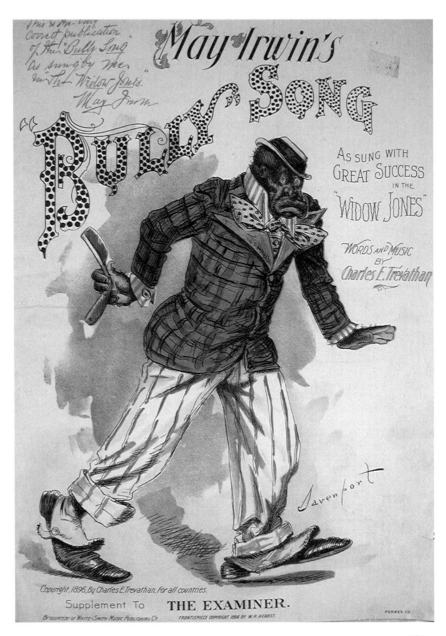

122

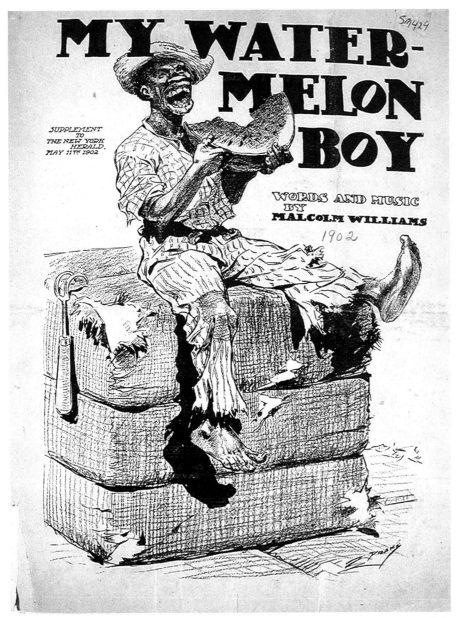

129

124. Date Box Lid
tin, 1930s–40s, Algeria. (4 × 8 ¹/₄)

125. Produce Label
paper, 1940s. "'Coon, 'Coon, Apricots." (4 ¹/₂ × 12)

126. Produce Label
paper, 1940s. "Mammy Yams." Lousiana, U.S.A. (9 × 10)

127. Soap Powder Box
paper, pre–World War I. "Fun to Wash." Instructions in English and German. Made in upstate New York where there was a large German community. (4⁷/₈ × 7³/₈ × 2 ¹/₂)

128. Record Album
cardboard and paper, 1940s. Victor Records, U.S.A. "Strictly From Dixie." (10 × 12 × ³/₄)

129. Sheet Music
paper, 1902. "My Watermelon Boy," supplement to the *New York Herald*. (9 ¹/₂ × 13)

130. Fan
paper and wood, 1940s, U.S.A. "Honey does you lub yo' Man?" Common advertisement giveaways from funeral homes. (13 × 8 ¹/₄)

131. Bric-a-Brac
bisque, 1920s, Northern Europe. The theme of fowl attacking a boy or man's penis is not uncommon. (6 × 4 × 2)

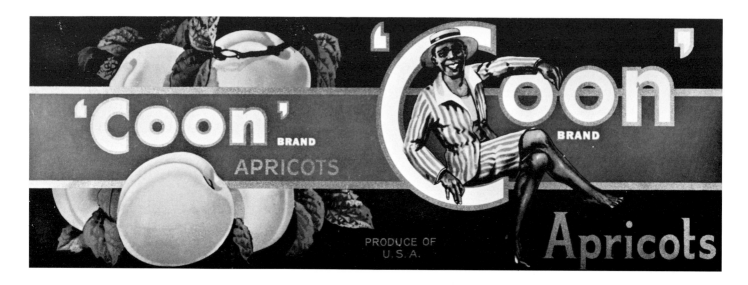

132. Candy Container
paper, 1930s, U.S.A. (12 x 8 x 4)

133. Sheet Music
paper, 1905. "There's a Dark Man Coming With a Bundle," published by the *Chicago Sun*. The inclusion of sheet music was once a common feature of Sunday newspaper supplements. (10 $^1/_4$ x 14)

134. Party Game
paper, 1940s, American Toy Works, New York. A game similar to "pin the tail on the donkey." (12 x 8 x 1 $^1/_2$)

135. Négro Cleansing Powder
cardboard and metal, 1950s, Montreal, Canada. (5 $^5/_8$ x 3 $^1/_4$ d.)

136. "Jacko" Michael Jackson Doll
wood, 1994. The nesting doll was made in Petersburg, Russia. (7 x 3 d.)

137. Advertising Card
cardboard, late 1800s. For Chase and Sanborn Coffee. (4 $^7/_8$ x 6)

138. Sheet Music
paper, late 1800s. "I Don't Care If Yo' Nebber Comes Back," Joseph W. Stern & Company. Representative of the "coon songs" promoted by Williams and Walker. (10 $^1/_2$ x 14)

139. Stereoscopic Viewing Card
cardboard, 1800s. By *Harper's Weekly*, U.S.A. (4 $^1/_8$ x 6 $^7/_8$)

140. Milk Pitcher
pottery, 1920. Weller Pottery Company, Ohio, for Ralston Purina Company (makers of Aunt Jemima Pancake Mix). Loan courtesy of Linda Bradley. (6 $^1/_2$ x 6)

141. Sheet Music
paper, c. 1900. "Let It Alone," published by Gotham Attucks Music Company, this depicts Bert Williams in blackface.
(10 $^1/_2$ x 14)

142. Pipe
meerschaum, mid-1800s, made in England. (6 $^1/_2$ x 3 x 2 $^1/_4$)

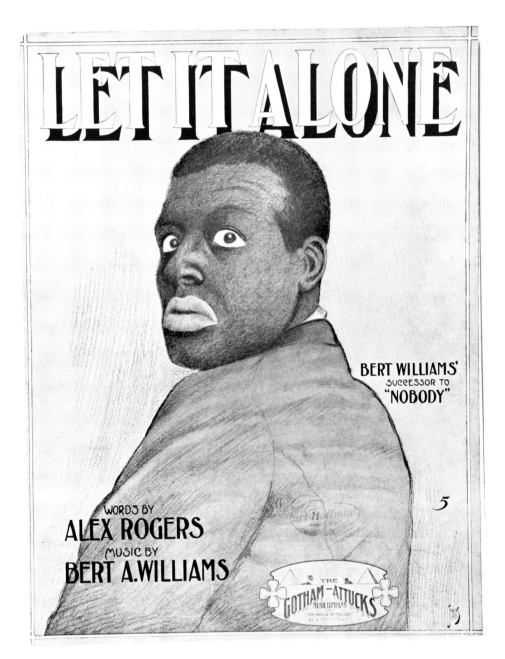

143. Doll
cloth, 1930s. The Topsy-Turvy doll originated during slavery. Prof. Patricia A. Turner refers to this as the "Topsy-Eva Doll." ($10 \times 5 \times 2\,^1/_2$)

144. Decanter
glass, 1857, Baccarat, France. ($14 \times 4\,^1/_2 \times 3\,^1/_2$)

145.
Sheet Music
paper, 1908. "Sumthin' Doin," by Andersloot Music Publishers, an example of *gratuitous caricature*, since there are no lyrics. ($10\,^1/_2 \times 14$)

146. Advertisement Cards and Display "Gold Dust Twins"
cardboard, early 1900s. Fairbanks Brothers Washing Powder Company later became Lever Brothers. (each: $3 \times 3\,^1/_2$)

147. Toy
metal with magnet, 1920. This hand-made, hand-held toy generates movement through body temperature. ($1\,^1/_4 \times 3$ d.)

148. Noisemaker Toy
tin, c. 1900, Germany. ($3 \times 2\,^1/_2$)

149. Mechanical Toy
tin, early–mid-1800s. Black and white boxer, made in France. ($6 \times 3 \times 7\,^1/_4$)

150. Hitching Post
cement, 1900. This is an example of the "faithful groom" lawn ornament. (27 x 12 x 11 ¹/₂)

151. Pickaninny Jackpot
cardboard and paper, 1940, U.S.A. A game of chance. (12 ¹/₄ x 14)

152. Firecrackers
paper and gunpowder, 1960, China and Macao. (2 x 3)

153. Ringholder
bisque, late 1800s, made in England. (2 ¹/₂ x 3 ³/₄)

154. Grocery List
wood, 1930, U.S.A. (7 x 11 x ¹/₄)

155. Cigar Box Label
paper, c. 1910. "Little African, A Dainty Morsel." (10 x 6)

156. Post Card
paper, 1900. "Buzzard Pete," Detroit Publishing Company. (3 ¹/₂ x 5 ¹/₂)

157. Post Card
paper, 1927. "Give Us De Rine," Ashville Post Card Company. (3 ¹/₂ x 5 ¹/₂)

158. Safety Instruction Flyer
paper, 1997, distributed to Pacific Bell employees. (5 ¹/₂ x 8 ¹/₂)

159. Liqueur Bottle
Robj, 1920s, France. (10 x 4 x 3 ¹/₂)

160. Currier and Ives Print
paper, 1892. "The Darktown Fire Brigade Slightly Demoralized," an advertisement for tobacco. (14 x 17)

161. Currier and Ives Print
paper, 1892. "The Darktown Race Won by a Neck." *See above.* (14 x 17)

162. Currier and Ives Print
paper, 1892. "Debate in the Darktown Club." *Same series as 158 and 159.* (14 x 17)

163. Minstrel Poster
paper, 1896. "Old Kentucky," Strobridge Litho Company, U.S.A. (30 x 40 ¹/₂)

164. Post Card
paper, 1940. "A Darkey's Prayer," Florida. (3 ¹/₂ x 5 ¹/₂)

165. Post Card
paper, 1900. "I hab eberyfing." Foreign-made. (3 ¹/₂ x 5 ¹/₂)

166. Sheet Music
paper, 1888. "Hie Away Ole Satan." White, Smith, and Company; Boston, Chicago. (10 ³/₄ x 14)

167. Post Card
paper, 1900. "Stripes But No Stars," S. H. Kress & Company, Germany. (3 ¹/₂ x 5 ¹/₂)

168. Post Card
paper, 1900. "Deed I Dun," American Post Card Co., U.S.A. (3 ¹/₂ x 5 ¹/₂)

169. Post Card
paper, 1950. "A Raise in the South," Thompson's Community Service (advertisement), U.S.A. (3 ¹/₂ x 5 ¹/₂)

170. Sheet Music
paper, 1910. "Play That Chopin Tune," Goldby Music Publishing Company, San Francisco. This is an example of razor imagery. (13 ³/₈ x 10 ¹/₂)

171. Post Card
paper, 1917. "The Blackville Serenade," Havens, U.S.A. (3 ¹/₂ x 5 ¹/₂)

172. Stereoscopic Viewing Card
paper and cardboard, late 1800s. "No Mas'r: Not 'Cause I Married Young, but I Is a Fas' Breeder." (3 ¹/₂ x 7)

173. Postcard
paper, 1905, "An Early Breakfast on a 'Dinah.'" Maker unknown. (5 ¹/₂ x 3 ¹/₂)

174. Stereoscopic Viewing Card
paper, 1879. "A Free Lunch," Keystone View Company, St. Louis, U.S.A. (3 ¹/₂ x 7)

175. Stereoscopic Viewing Card
paper, 1897. "I'se a Little Alabama Coon," Keystone View Company. (3 ¹/₂ x 7)

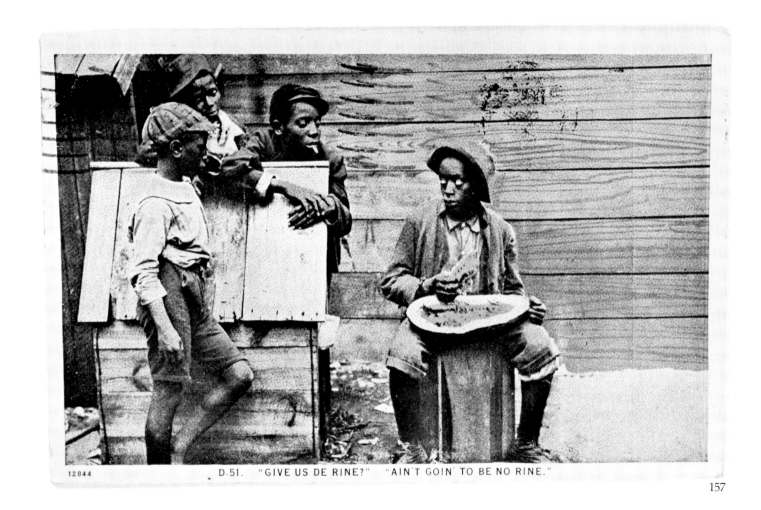

D-51. "GIVE US DE RINE?" "AIN'T GOIN' TO BE NO RINE."

157

176. Stereoscopic Viewing Card
paper, 1897. "I's boun to hab a Christmas Dinner" Keystone View Company. (3 1/$_2$ x 7)

177. Candle
wax, 2000, Berkeley. (7 x 2 1/$_4$ x 1)

178. Souvenir Spoon
sterling silver, 1900. Marked "s, Huntsville, Alabama," depicting watermelon and cotton. (4 x 1 x 1/$_2$)

179. Souvenir Spoon
sterling silver, 1900, marked "Daytona." (6 x 1 1/$_4$ x 1/$_2$)

180. Souvenir Spoon
silver with gold wash bowl, 1900. Marked "New Orleans." Manufacturer unknown. (5 5/$_8$ x 1 1/$_4$ x 1/$_2$)

181. Souvenir Spoon
sterling silver, 1900. Marked "Jacksonville, Florida," manufacturer unknown. (5 3/4 x 1 1/4 x 1/2)

182. Souvenir Spoon
sterling silver, 1907. "Two Coons," Paul Gale, Greenwood Company, U.S.A. (6 x 1 1/4 x 1/2)

183. Christmas Ornament
bread dough, contemporary, made in the San Francisco Bay Area. (4 x 2 1/2)

184. Souvenir Spoon
enamel and silver, 1897. Manufactured by Charles W. Cranks, U.S.A. (3 7/8 x 7/8 x 1/2)

185. 4 Pages from *San Francisco Examiner*
paper, 1899. "Four Comic Stories: The Tragic Fate of 7 Little Niggers, Cinderella Johnsing and the Brass Slipper, The True Story of Little Red Riding Hood, The Coons Fell into the Soup." (each: 14 1/2 x 19 1/2)

186. Toy
tin, early 1900s. "Windup Mammy Doll," Lindstrom Toy Company, U.S.A. (8 x 3 1/4 x 3 1/4)

187. Candy Box
tin, 1920s, made in Germany. (3 1/2 x 5 3/4 d.)

188. Incense Burner
cast iron, late 1800s, U.S.A. (6 3/4 x 3 x 2 3/4)

189. Jemima Mask
ceramic, 1995, made by "Moni Blom" and purchased at a San Francisco Bay Area crafts fair. (4 x 3 1/2 x 1 1/2)

190. Palmer Cox's "Brownie"
various materials, early 1930s, from Playland at the Beach in San Francisco. Cox was an illustrator who created the trouble-making imp. (41 x 18 x 11 1/2)

191. Souvenir Spoon
sterling silver, 1900, Tampa, Florida, marked "GK." (5 3/8 x 1 1/8 x 1/2)

192. Child's Bowl
ceramic, c. 1900, made in England. (2 x 5 1/4)

193. Aunt Jemima Pancake Mix
cardboard, 1980s, made in Venezuela. (4 1/4 x 3 3/4 d.)

194, 195. Fairbanks Washing Powder and Scouring Powder
paper, cardboard, early 1900s. Originally, the Fairbanks brothers portrayed themselves on their label, but it was not until they changed it to "The Gold Dust Twins" that the powder began to sell well. The logo became very well-known. (6 x 9 x 3 & 4 1/4 x 3 d.)

196. Puppet
wood, 1930s, made in the U.S.A. (17 x 4 x 2 3/4)

197. Letter Opener
biskoline, early 1900s, made in Germany, manufacturer unknown. The cigar is removable and serves as a pencil. (11 3/4 x 3/4 x 1 3/8)

198. Cocktail Napkin
paper, 1990s, Italy. (5 x 3 1/4)

199. Sugar
paper packet containing sugar, 1990s, Italy. (2 1/2 x 2)

200. Coaster
paper, 1990s, Czech Republic. (3 1/2 d.)

201. Sculpted Head
ivory ?, Art Deco period? Probably French. (7 1/2 x 8 d.)

202. Book
paper, 1939, 1963, *Ten Little Niggers* by Agatha Christie, published by Fontana Books, Collins: London and Glasgow. Copyright 1939, this edition was printed in 1963. (4 1/8 x 7)

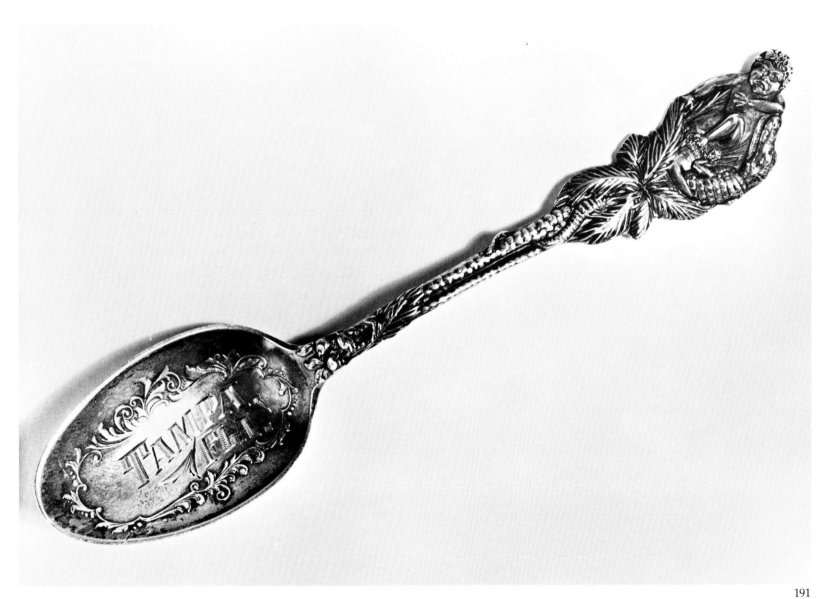

191